My heartfelt thanks to Helen for her on-going support of my pursuits and my most sincere gratitude to Edwin for contributing a thoughtful forward and daily summaries, Jean-François and his amazing efforts in pulling together an unparalleled festival for North America and to the artists that have allowed me the privilege of photographing them while deeply entrenched in their craft.

This photobook contains a small sample of photos from the festival. If you would like to see more photos, visit photo.onsendesigns.com

Contact:

Onsendesigns Photography
http://photo.onsendesigns.com

Kinetik Productions
http://www.festival-kinetik.net

Photographs © 2013 Adrian Onsen / Onsendesigns Photography / Kinetik Productions
Published by Kinetik Productions 2013

Adrian Onsen retains sole copyright to the images used in this book.
No part of this book may be reproduced or transmitted in any form and by any means without the prior written permission of Kinetik Productions.

For promotional purposes only. Funds raised from the sale of this books are donated to Kinetik Productions.

KINETIK

LA FORCE VIVE • FESTIVAL ELECTRO/INDUSTRIEL/NOISE/HARDCORE
THE INNER FORCE • ELECTRO/INDUSTRIAL/NOISE/HARDCORE FESTIVAL

Après le succès des premières éditions, l'énergie cinétique revient mettre en mouvement les corps avec sa force vive du 23 au 26 mai 2013 pour une "mini" édition, pour célébrer la musique électro-industrielle-noise-ebm. Ne manquez pas le retour de ce festival international qui, pour sa sixième édition, vous présentera encore une fois un survol de l'évolution de la culture électro-industrielle-noise-ebm de 25 dernières années avec plusieurs groupes internationaux et une place spéciale pour la découverte des talents canadiens.

After the success of the first editions of the festival, the kinetic energy urges the body to move with its momentum from 23 to 26 of May 2013 for a "mini" festival, and celebrate the Electro, Old School, Harsh Industrial, Rythmic noise and EBM sub-culture music. Do not miss the return of this international festival in it's fifth year where the the festival will once again feature the evolution of the preceding 25 years of electro-ebm-industrial-noise culture, with many international groups and a special place for the discovery of Canadian talent.

www.festival-kinetik.net

$$E_k = \tfrac{1}{2}MV^2$$

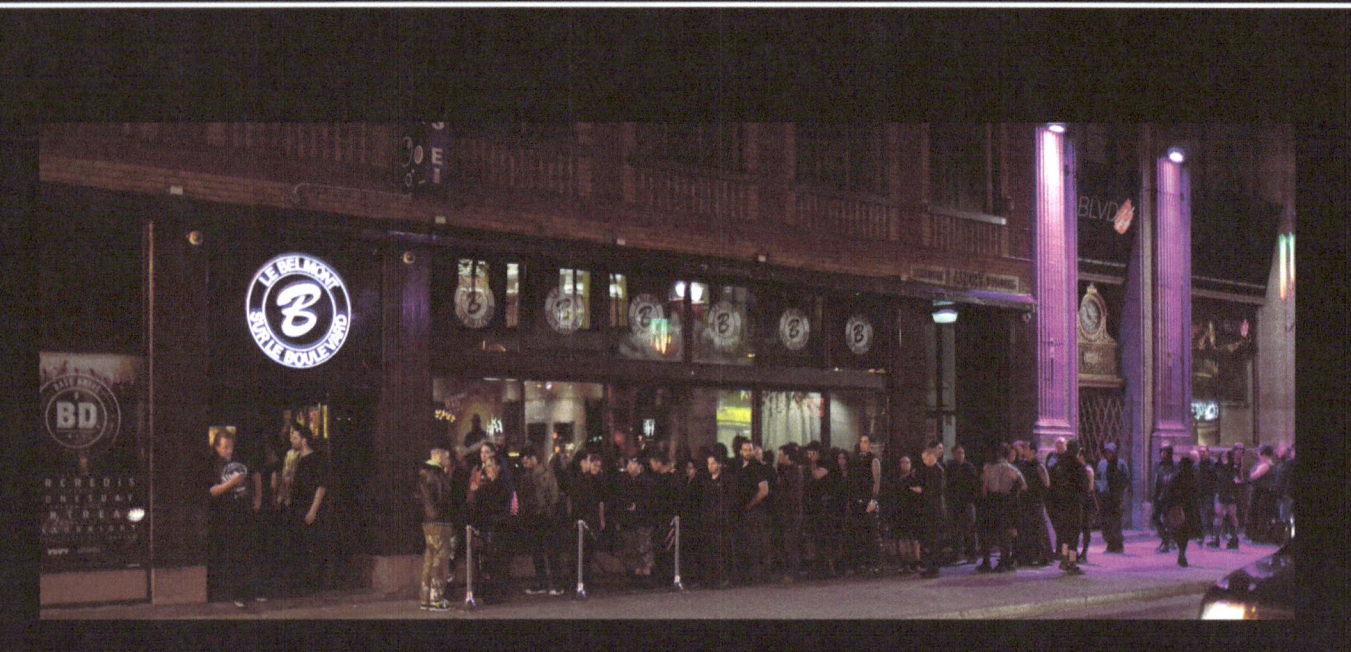

FORWARD

Every year, the days leading up to the Kinetik festival are packed with an incredible air of excitement. Kinetik 5.5 was touted as a smaller scale festival, pulled together at the last minute in a year where there was likely going to be no festival. And yet despite its cutbacks, there was no less buzz amongst Industrial music enthusiasts. Maybe that says something about us; that in times of adversity, we bind together and look for ways to fight back against the threat of being consumed.

And there's no questioning that the community bound together this year. Even though it was arguably the smallest scale Kinetik ever put on, the intensity of camaraderie and positivity was at an all time high. And even though the lineup was pulled mainly from the finest acts in the Toronto-Montreal-Ottawa region, there were huge international acts clamouring to play as well; a true testament to the global strength and recognition of Kinetik.

For most of us coming from outside of Montreal, we had no knowledge of this new venue, Le Belmont. Certainly it wouldn't be as cavernous as the previous venue Metropolis, but would it hold up to the needs of the festival? With multiple rooms and bars, a decent stage, an incredibly powerful sound system, and a top notch backstage area, the venue was more than up to the challenges that four days of live performances could dole out, even if at times we all had to get a little close.

I hope this book, put together by the incredibly talented Adrian, brings back fond memories of the festival for those in attendance, or sheds some light on the experience of being there for those who weren't able to make it. Most of all, I hope it serves as a reminder of the strength of our music scene when we are under the gun and determined to celebrate our culture.

Here's to Kinetik 5.5. And to many more Kinetiks yet to come.

Edwin Somnambulist

Classically, on the first phase of Kinetik, you can feel the anticipation that builds up over many months in the air and people who haven't seen each other in ages come together with a burst of joy. This year, phase one was meant to be an opening night, a taste of what the rest of the festival would bring, but if that was indeed the case, you couldn't tell by the reactions of the attendees and the energy of the artists on stage. MyParasites opened the evening, and despite it being their first year at Kinetik, they took to the stage with a killer performance. Project F stole the show that evening, decked out in body paint, with their high energy metal-laced industrial, and Life Cried and DYM closed out the evening with some stomping tunes.

PHASE 1

MyParasites	08
Projekt F	10
Life Cried	12
DYM	14

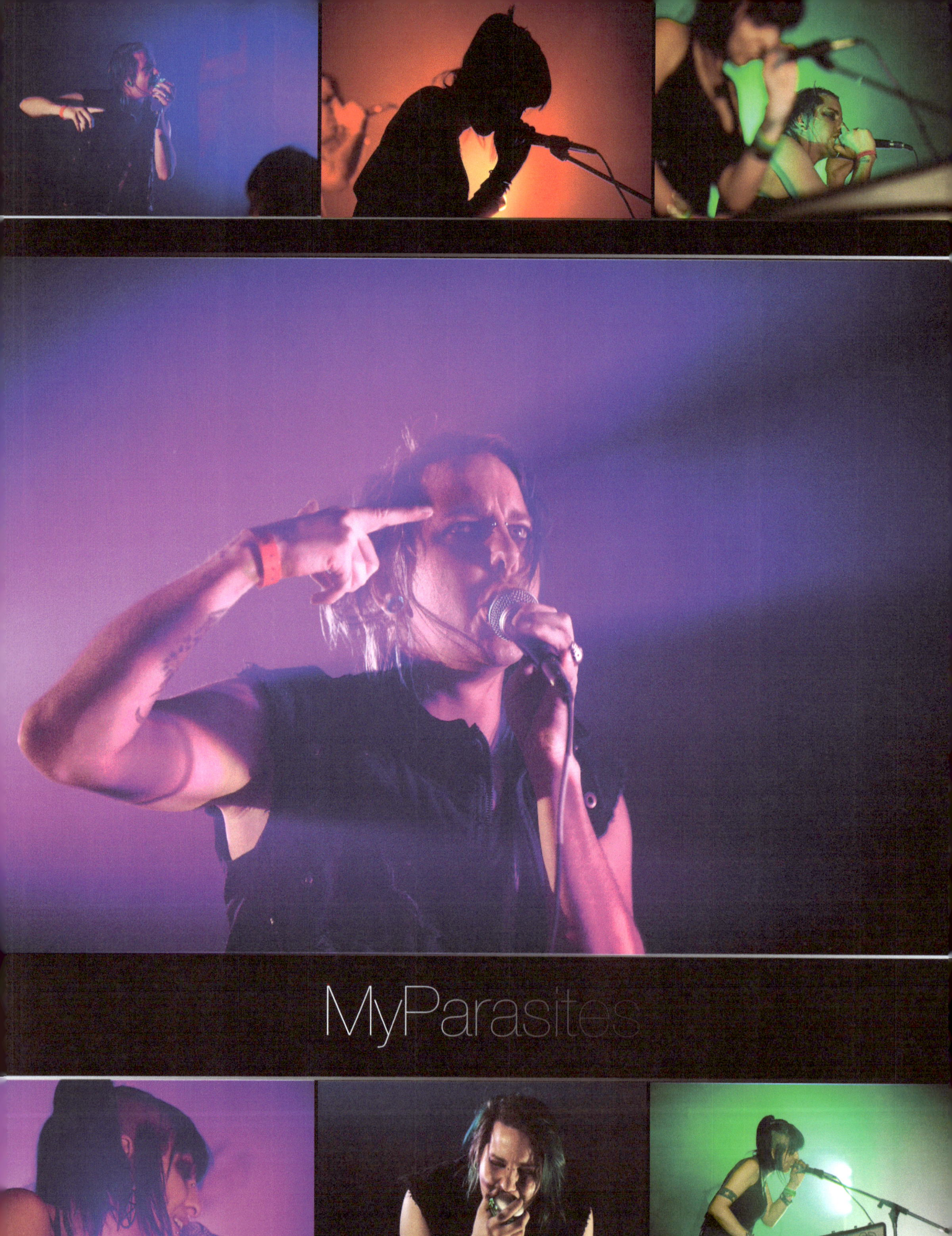

MyParasites

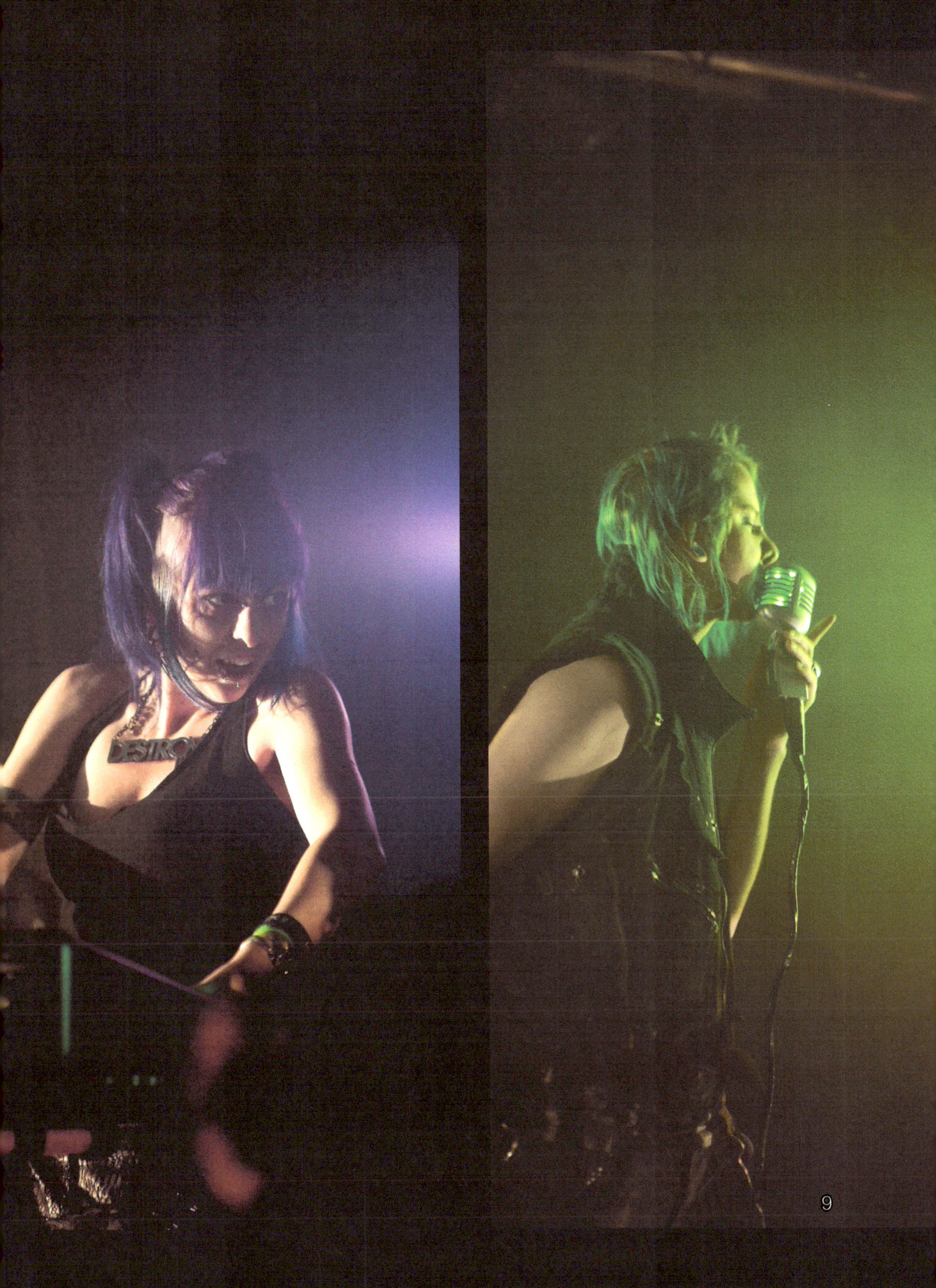

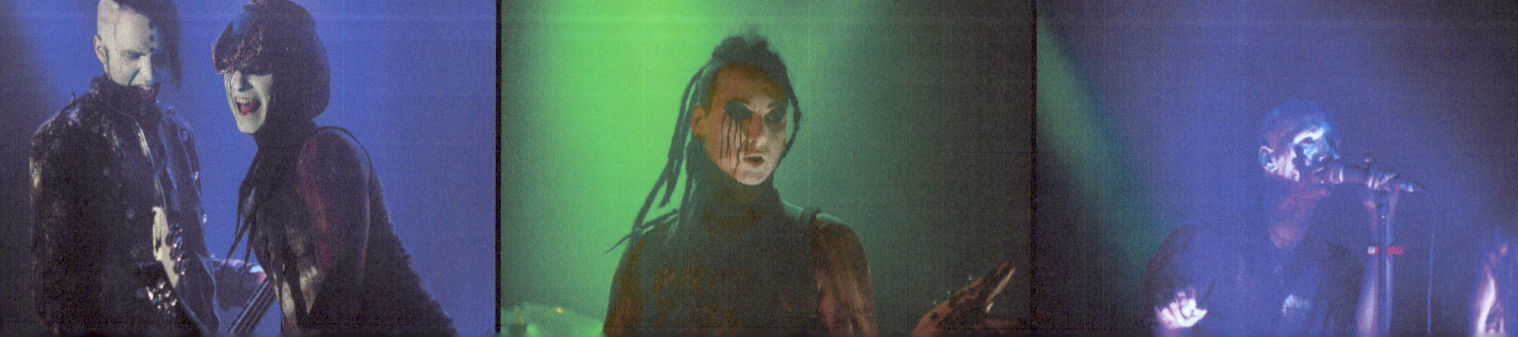

Pröjekt F

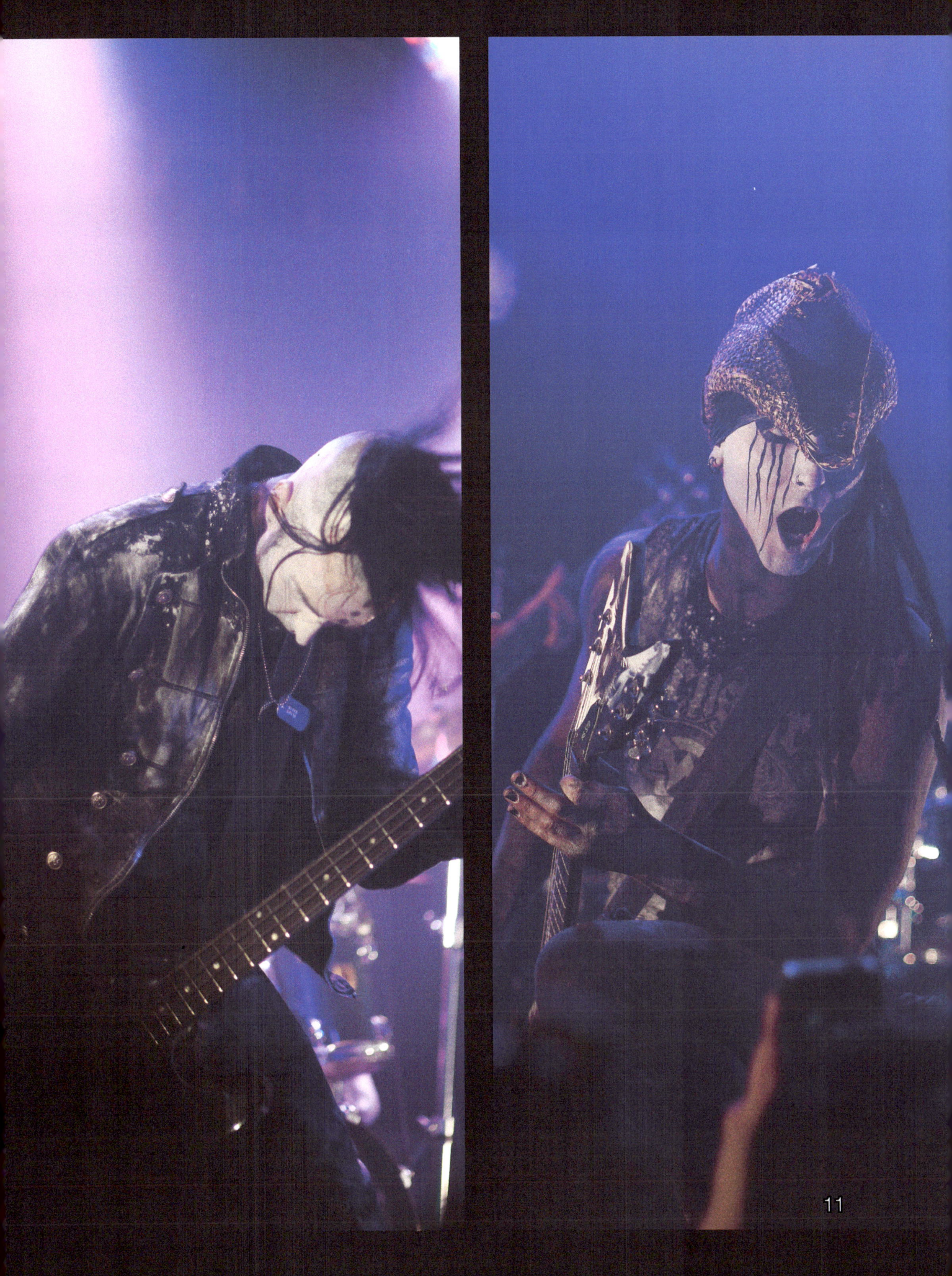

Life Cried

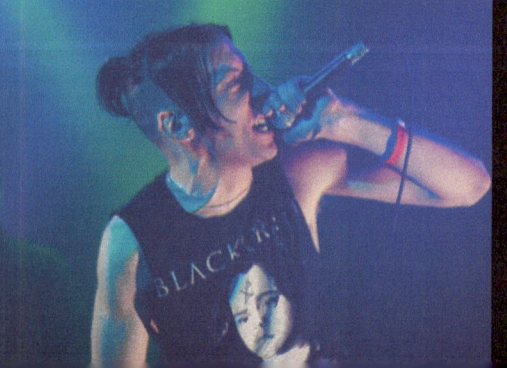
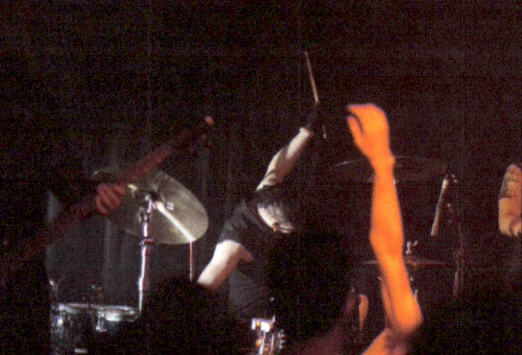

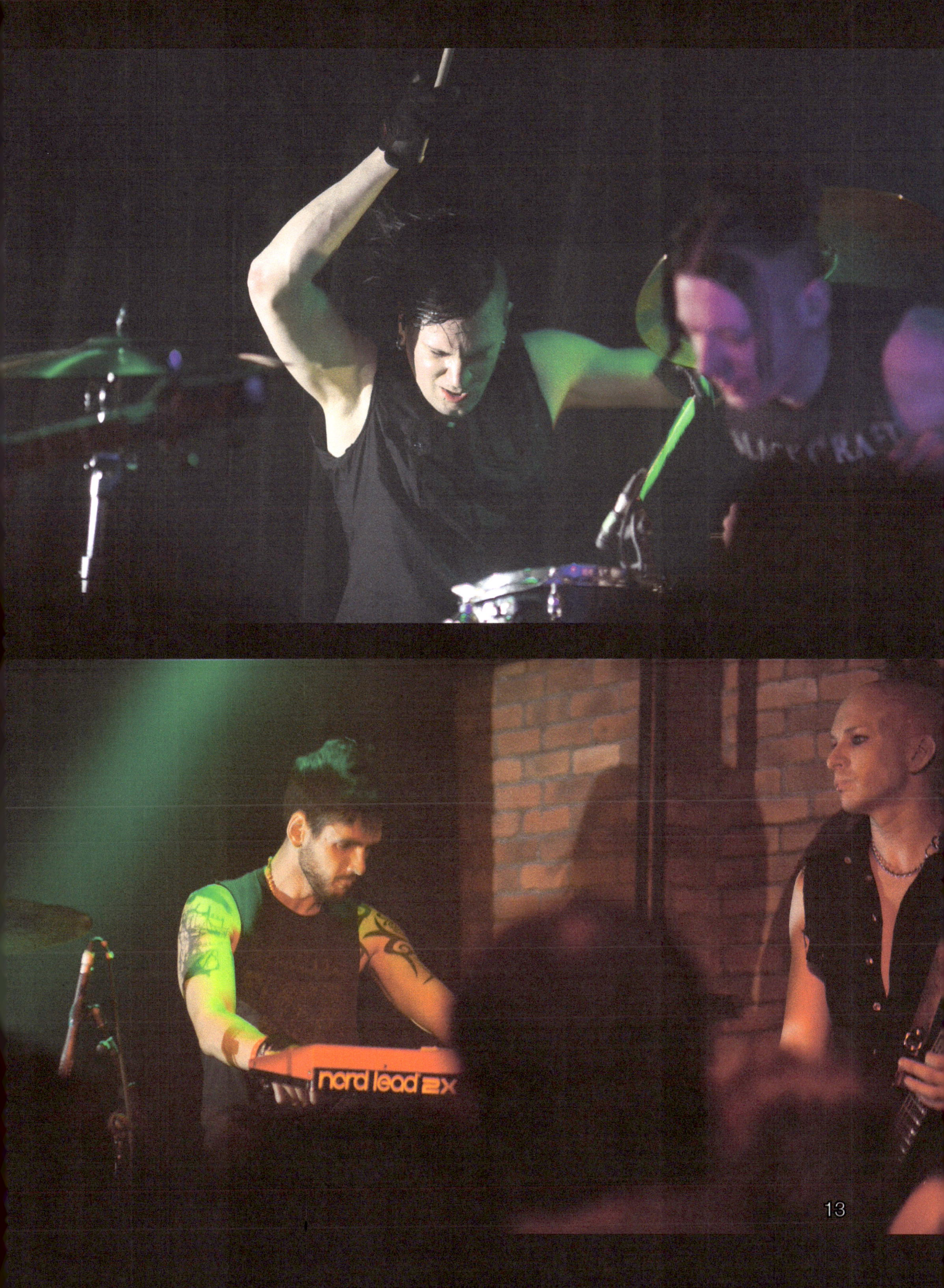

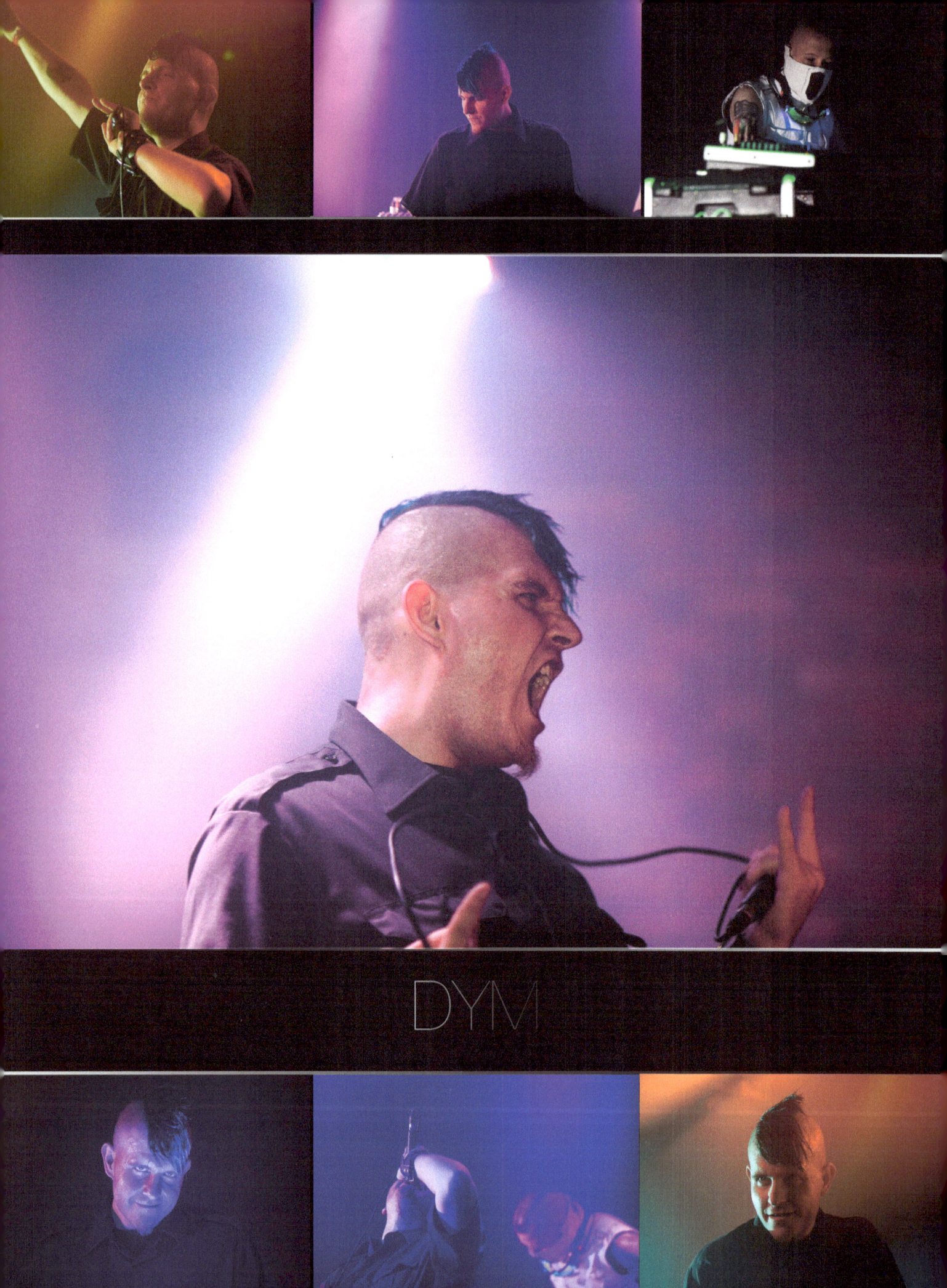
DYM

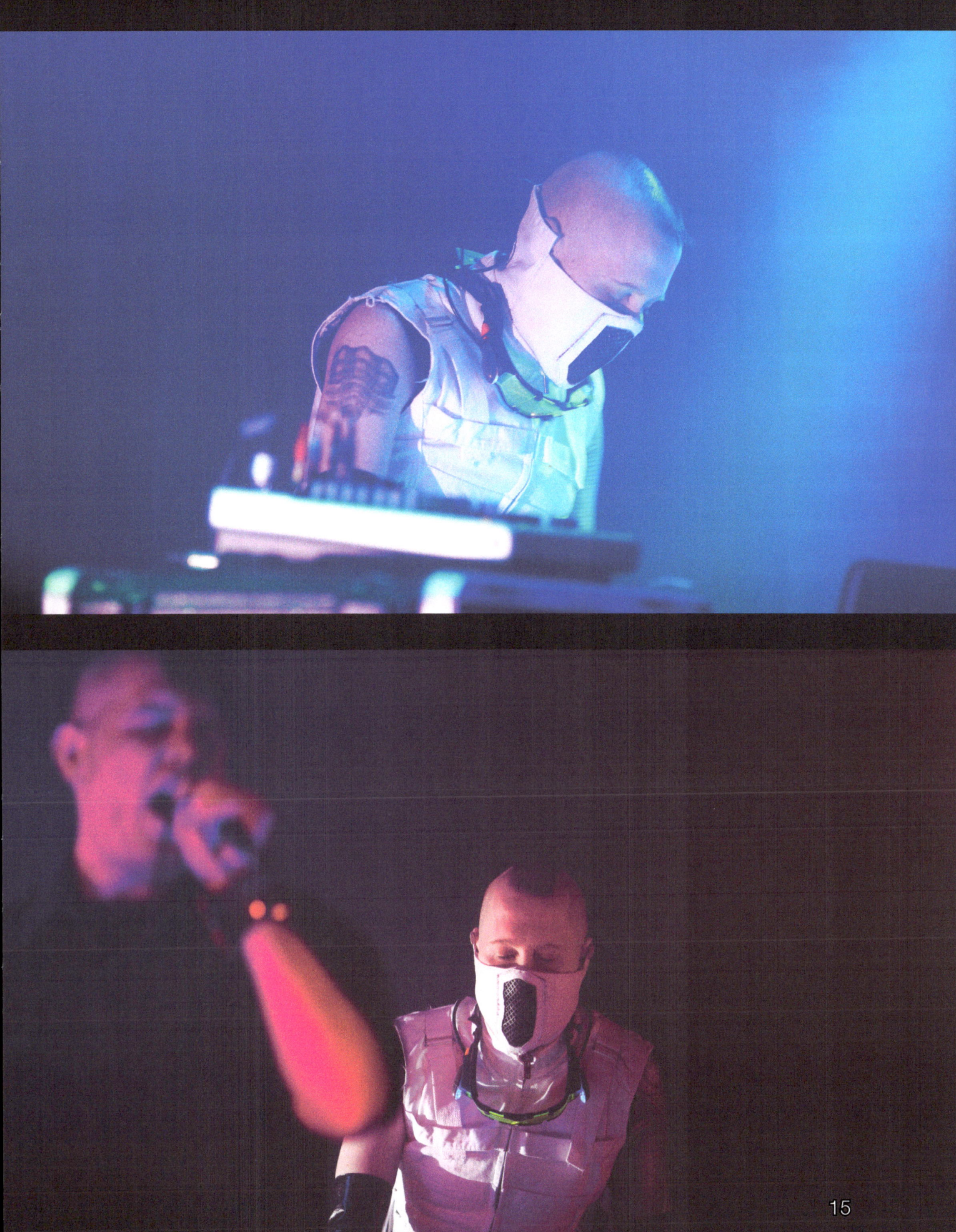

With the first night in the rearview, phase 2 brought with it a ton of hype. This was the first night with a full-length lineup and an international headliner. Suicide Commando, who had only played outside of Europe a handful of times, for many people this would be their first, or only, opportunity to see the legend of terror industrial. The A was packed to capacity this night, with crowds so tight around the stage that it was difficult to move, bringing back memories of some of the classic industrial concerts I've attended. FGFC820's show was not to be missed; their special branding of music, and their ability to constantly engage and relate to their audience makes them a favourite act wherever they play. Phase 2 was overloaded with talent, as the fans in attendance were treated to high energy performances from Nitronoise and Frontal Boundary.

PHASE 2

Nitronoise	18
FGFC820	20
Suicide Commando	22
Frontal Boundary	24

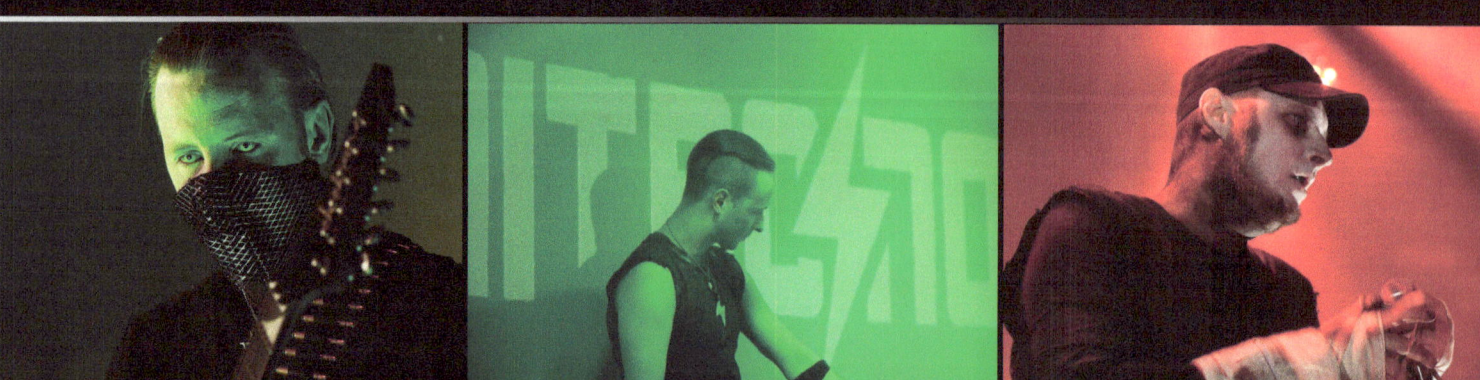

Nitronoise

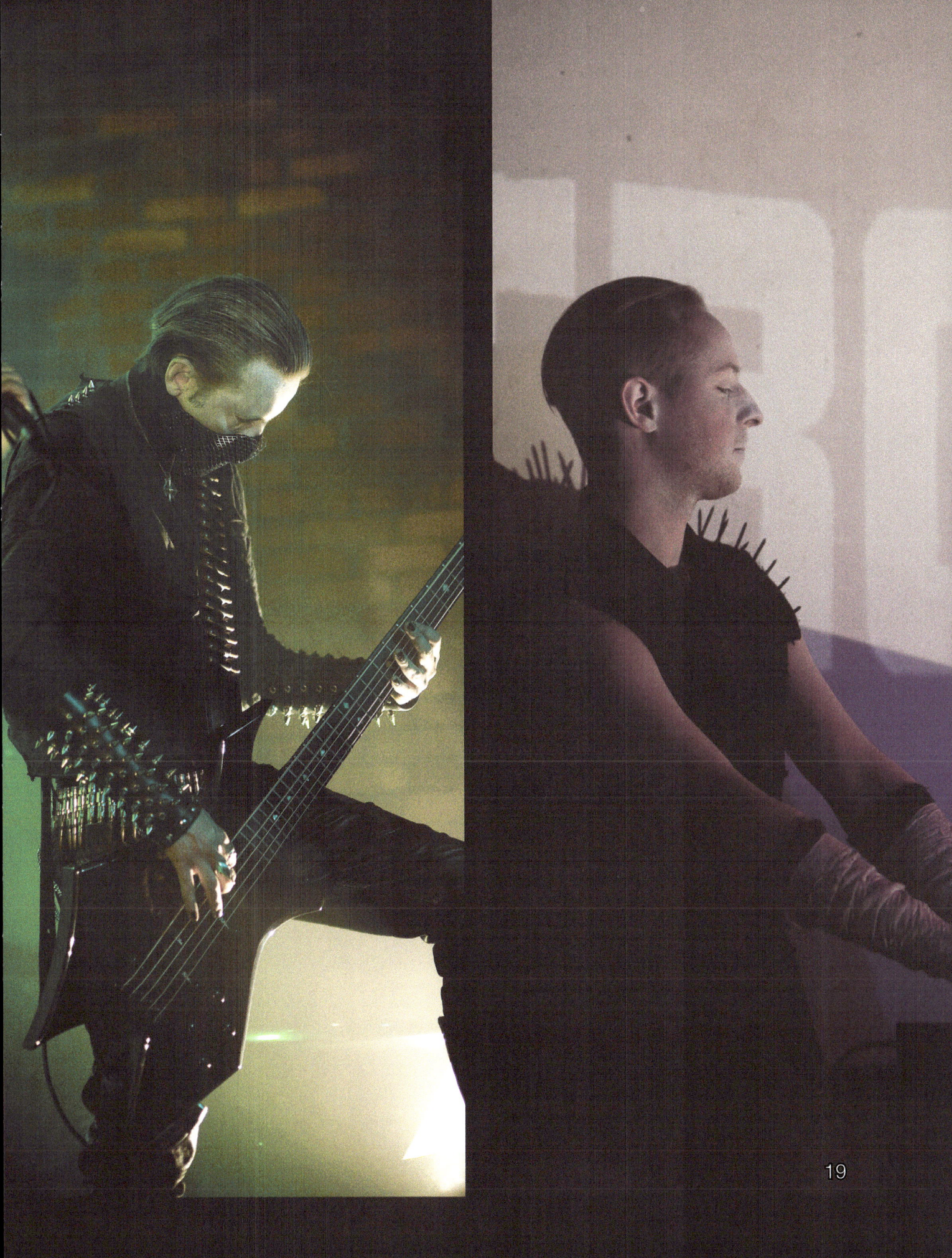

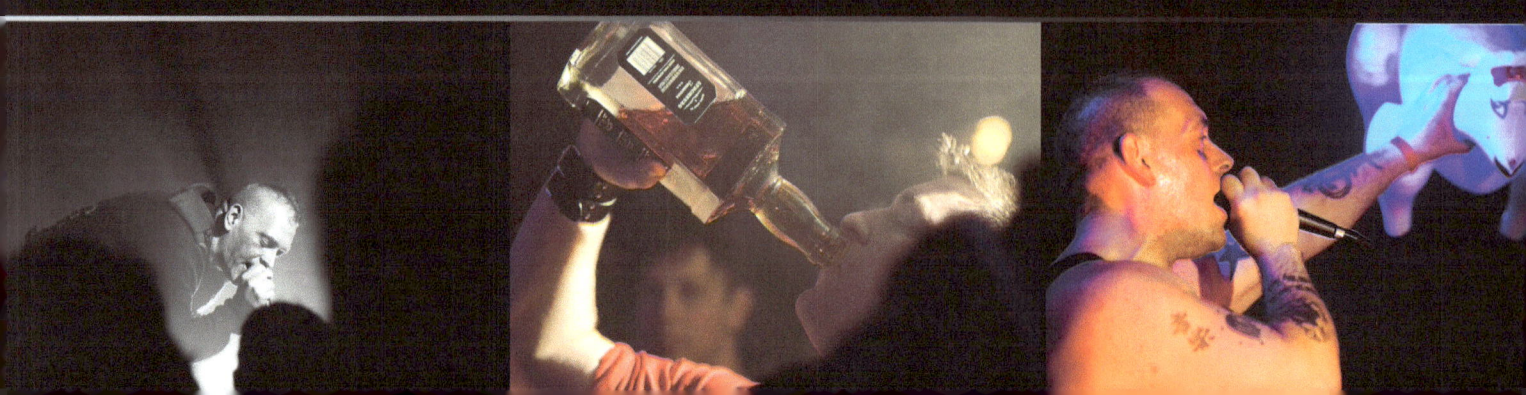

FGFC820

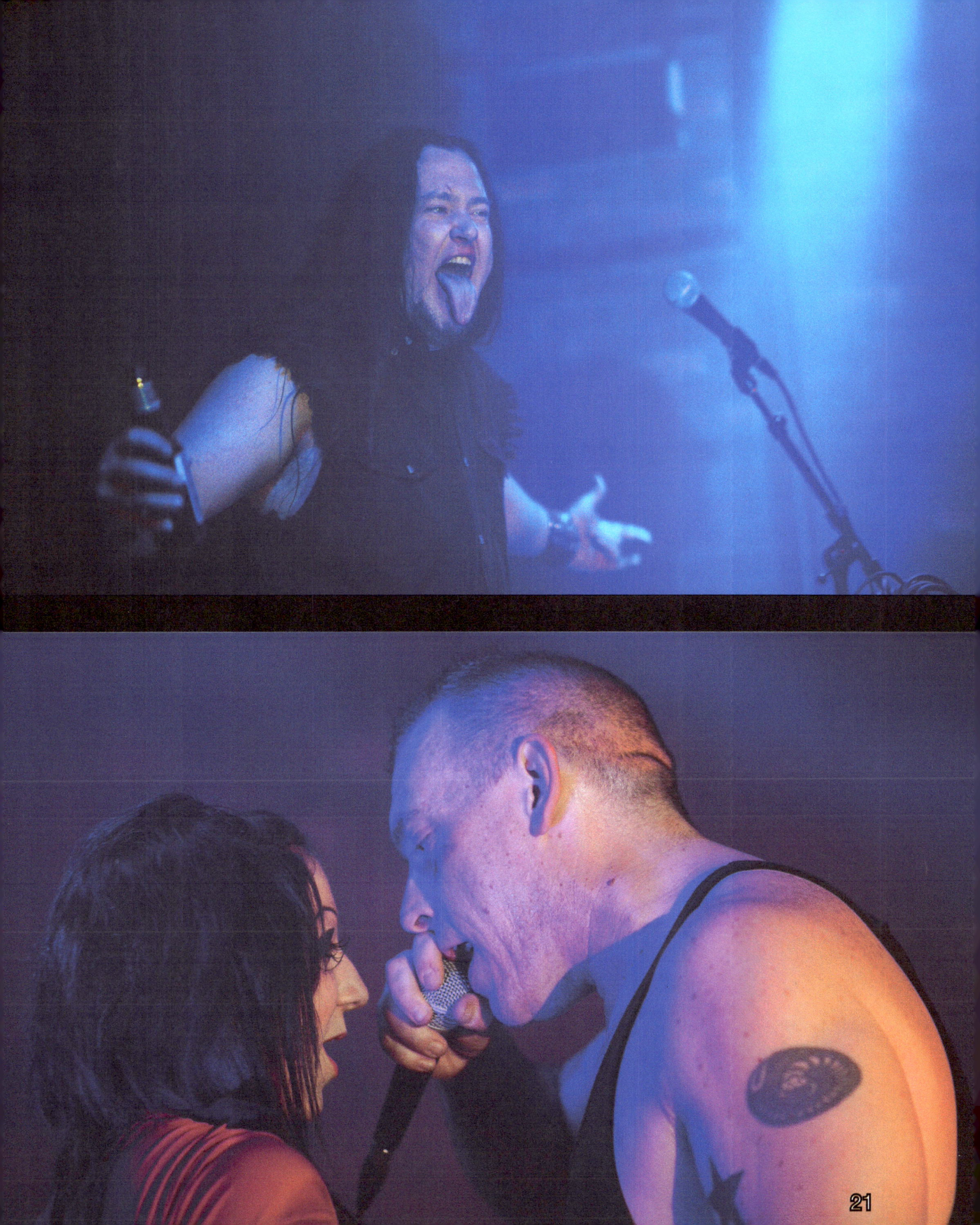

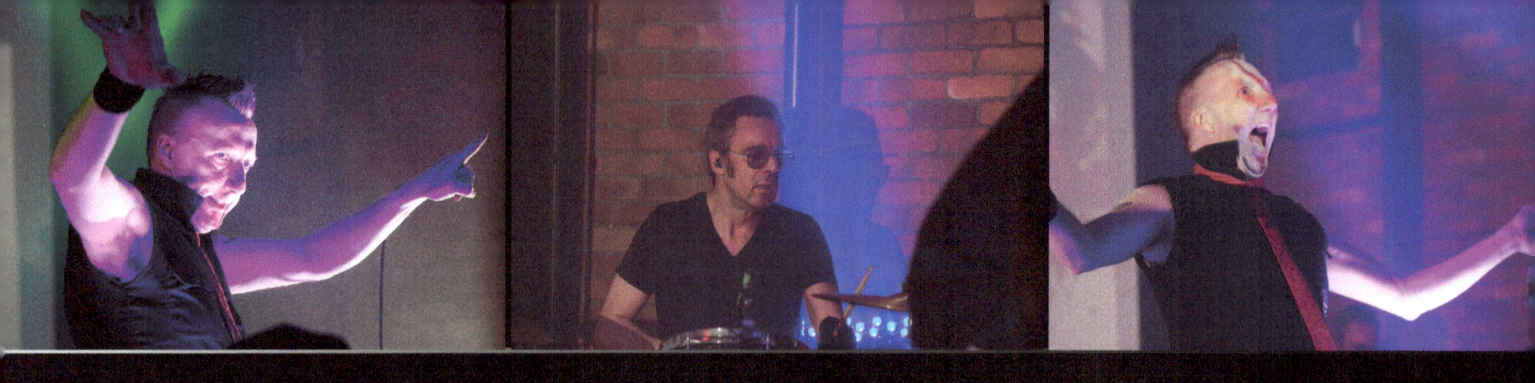

Suicide Commando

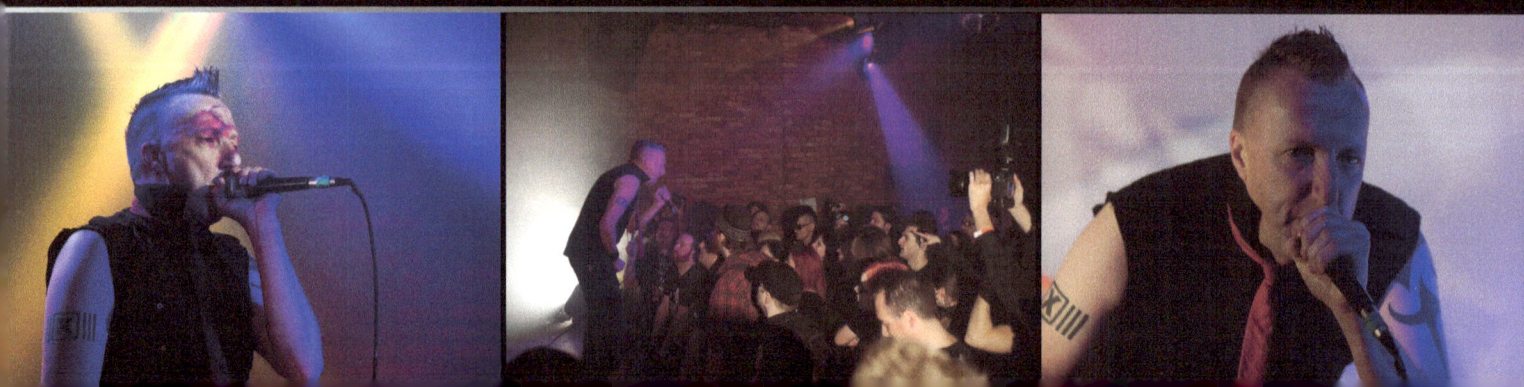

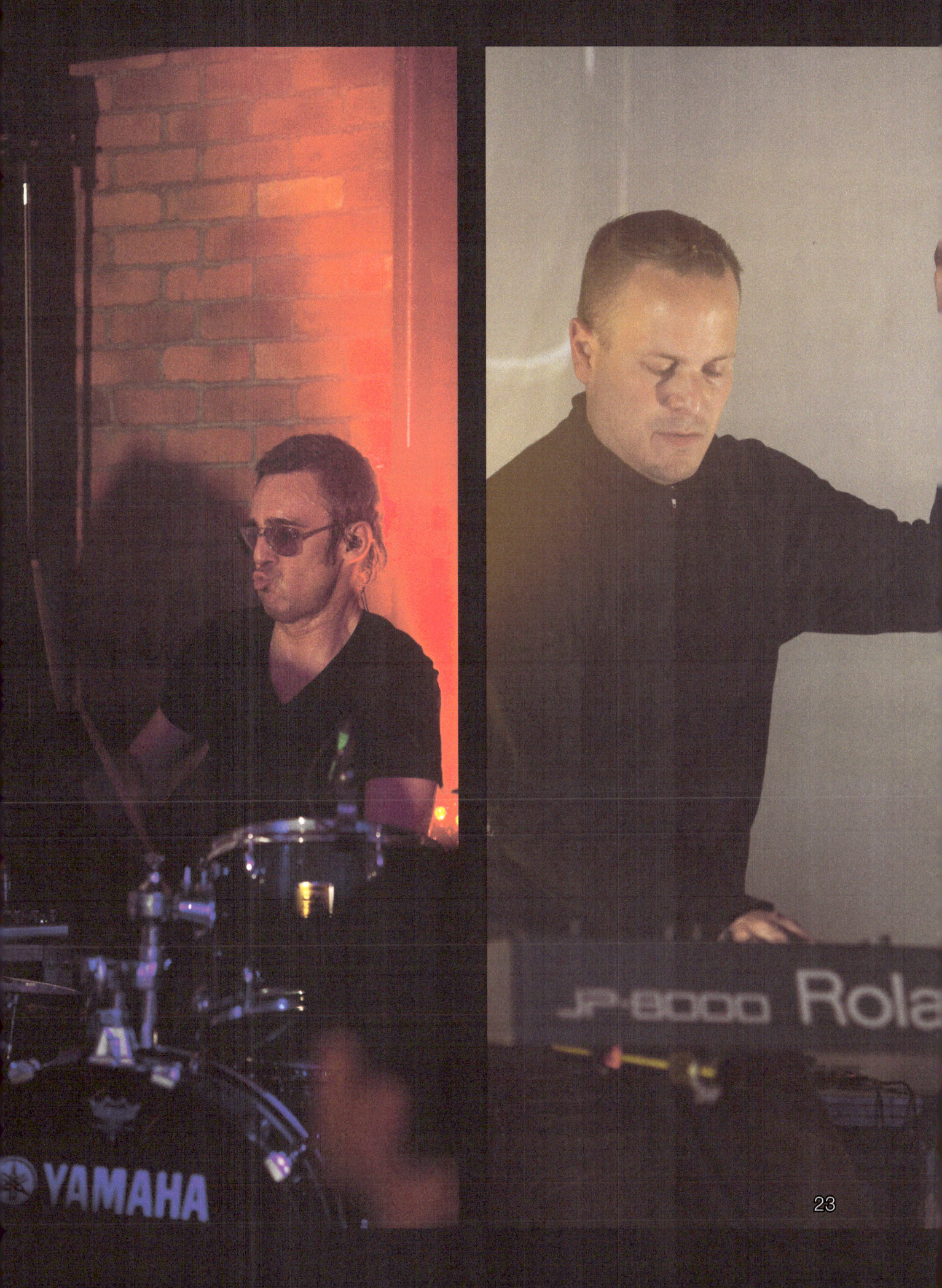

Frontal Boundary

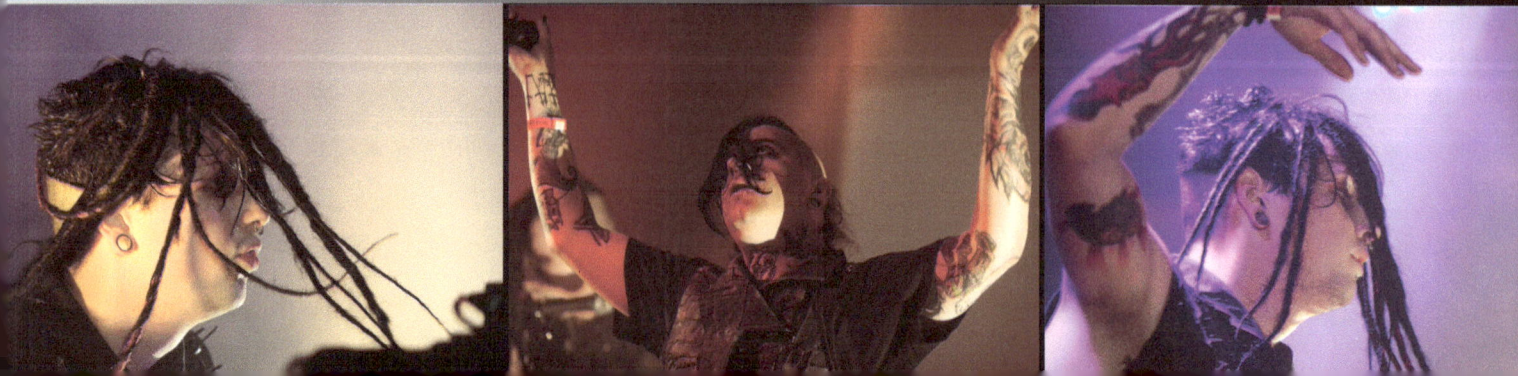

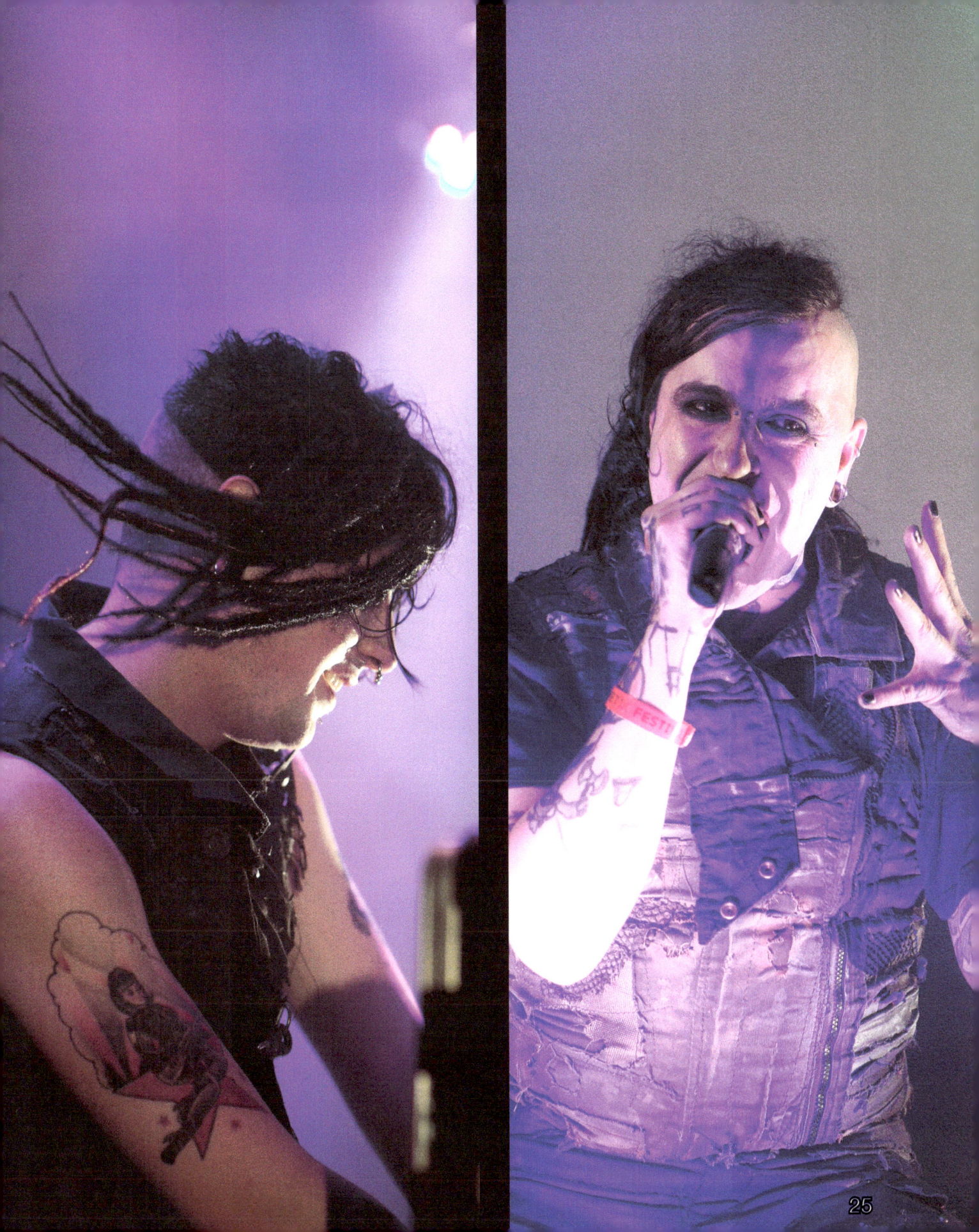

After the soul-trembling performances of phase 2, phase 3 was a bit of a hump day at the festival. With two days down and two to go, there's a strong temptation to take a nap to summon energy before the festivities start; missing bands is just not an option. One thing that is always true about Kinetik is that if you miss even five minutes of the festival, you may miss something truly incredible, something you'll never see again. And Cenotype brought one of those moments when they put aside their brooding industrial sound for one track and summoned members of The Gothsicles and FGFC820 to the stage to do a cover of Bronski Beat's "Hit That Perfect Beat". Terrorfakt's theatrics later in the evening enthralled the crowd, showering people in sparks from their on-stage construction equipment. By the time the headliner Aesthetic Perfection went on, you could feel the frenzy the crowd had been worked into, and between frontman Daniel Graves and the evening's closing act Tonikom, the crowds were both dazzled and hypnotized to round out the day.

PHASE 3

Displacer	28
Cenotype	30
Decoded Feedback	32
Terrorfakt	34
Aesthetic Perfection	36
Tonikom	38

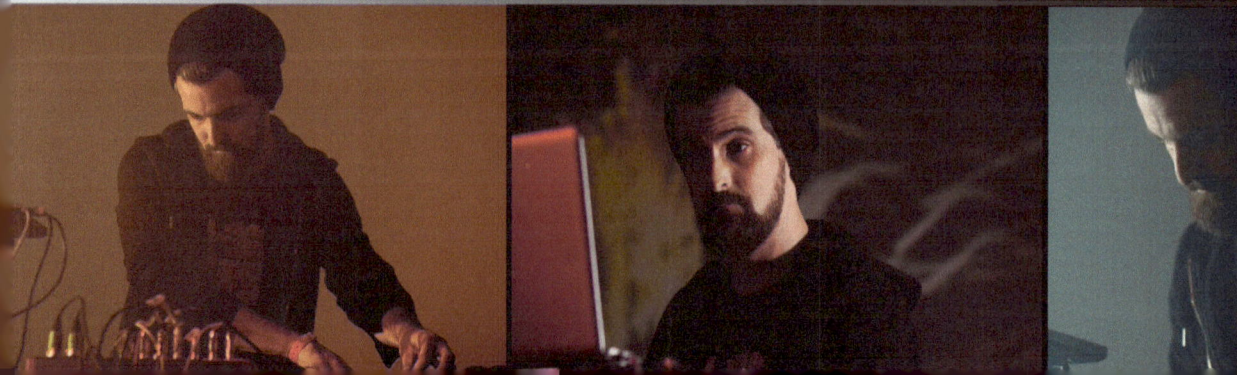

Displacer

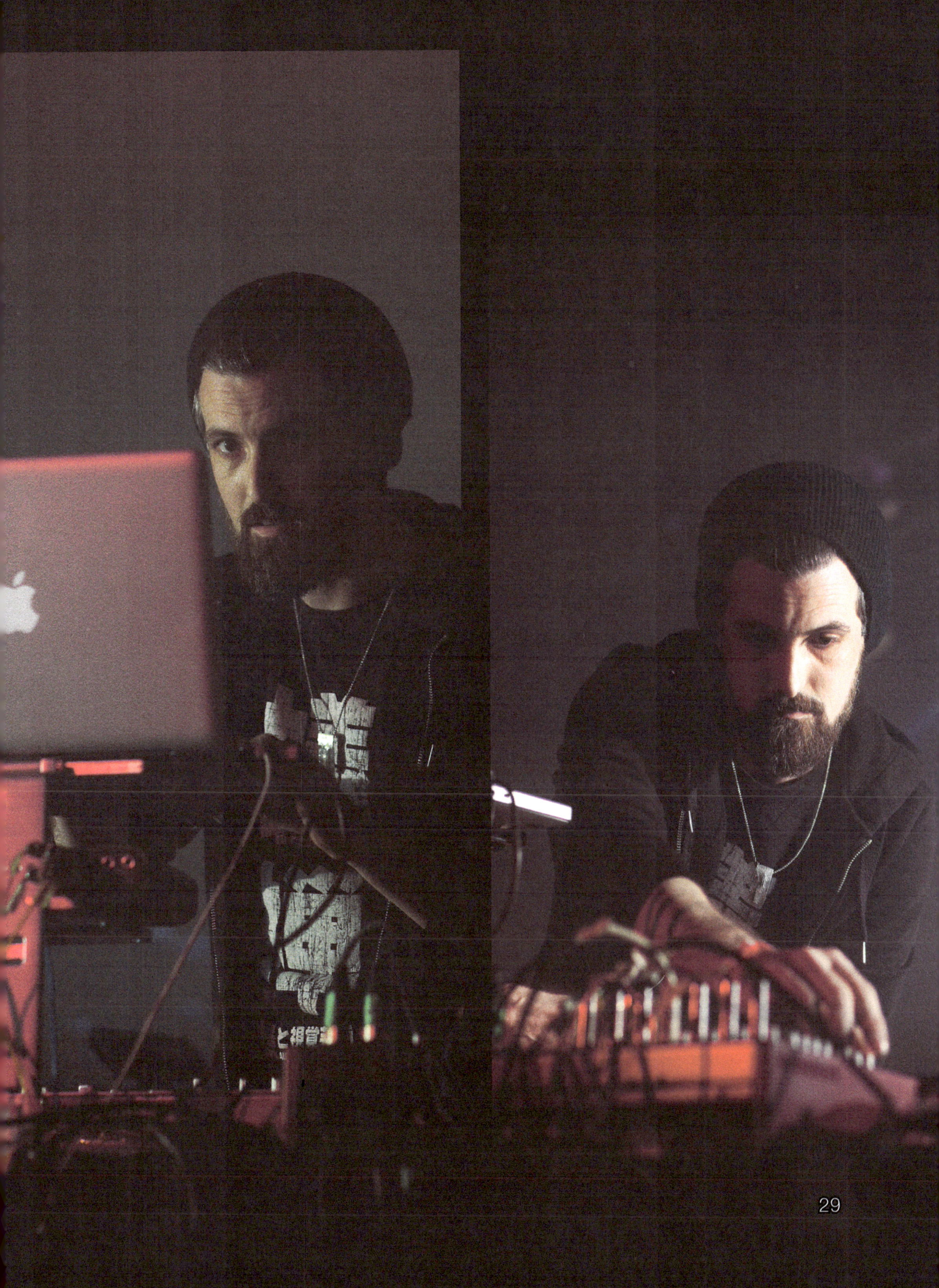

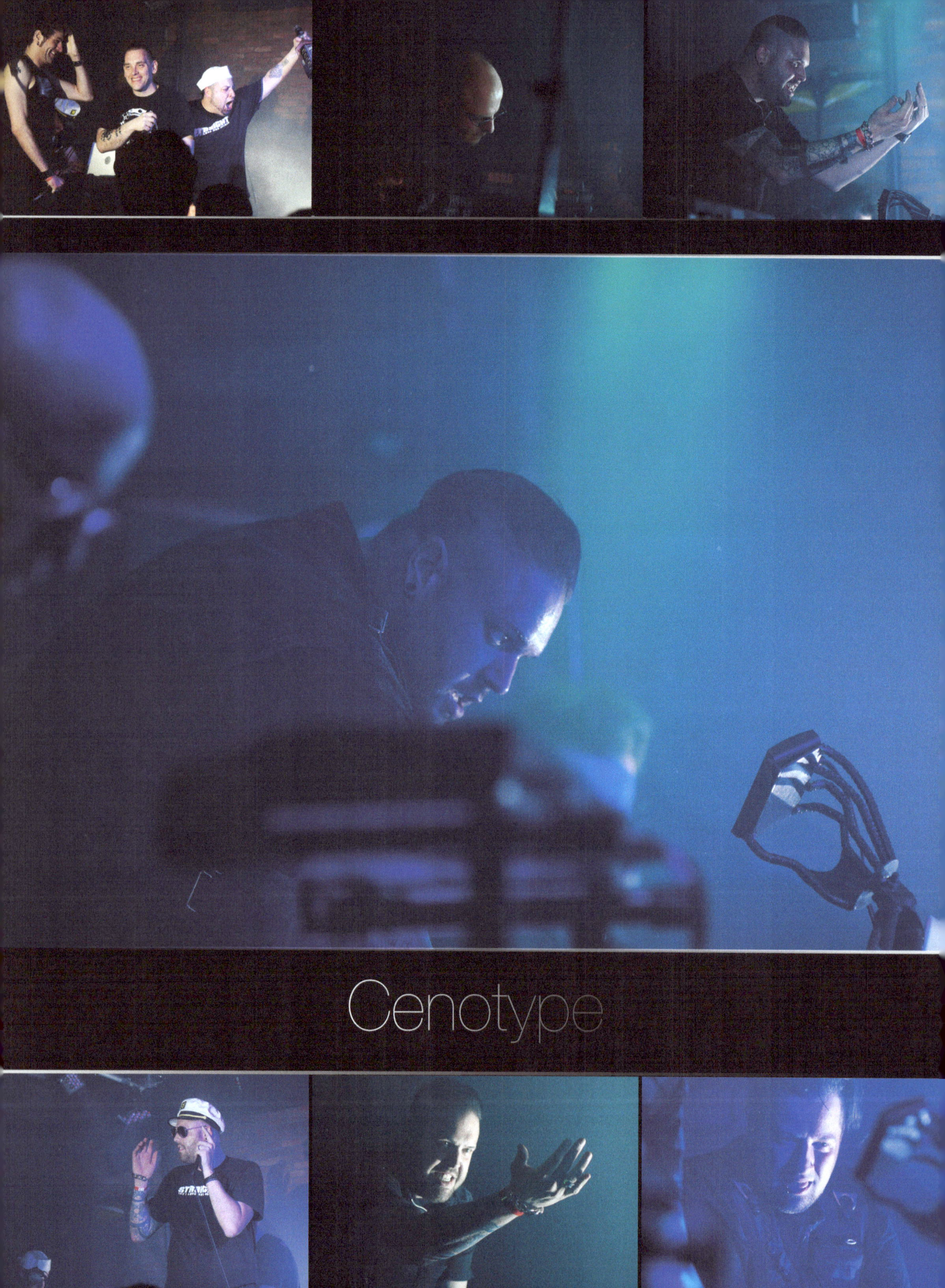

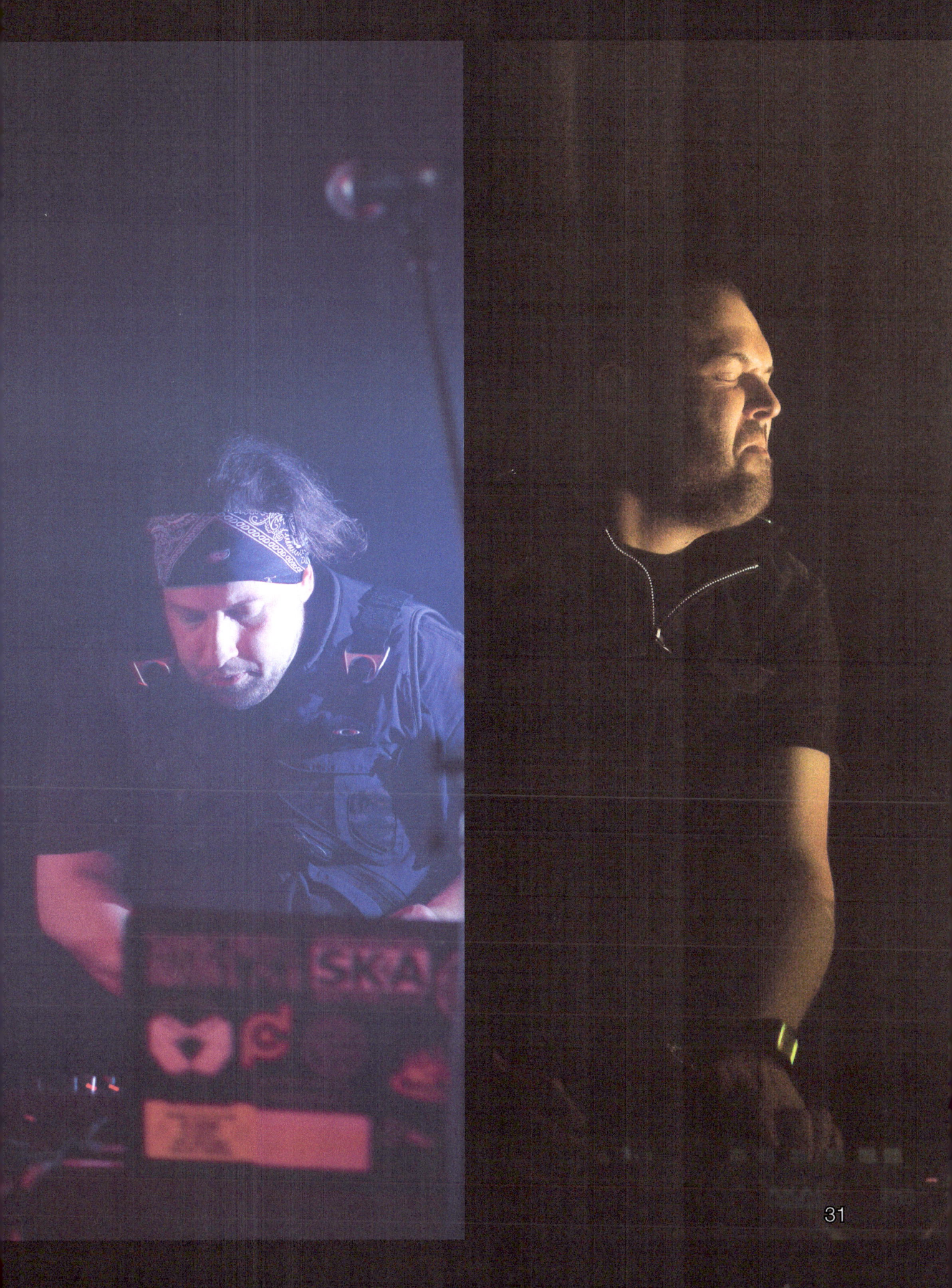

Decoded Feedback

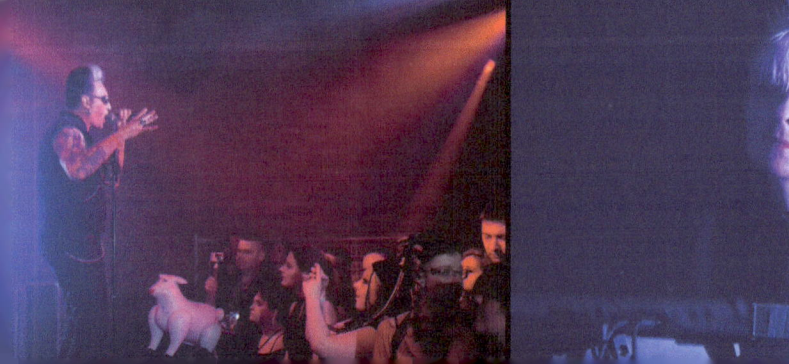

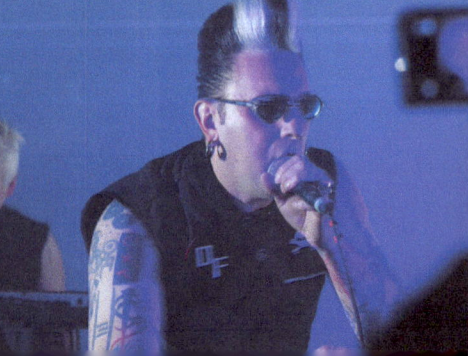

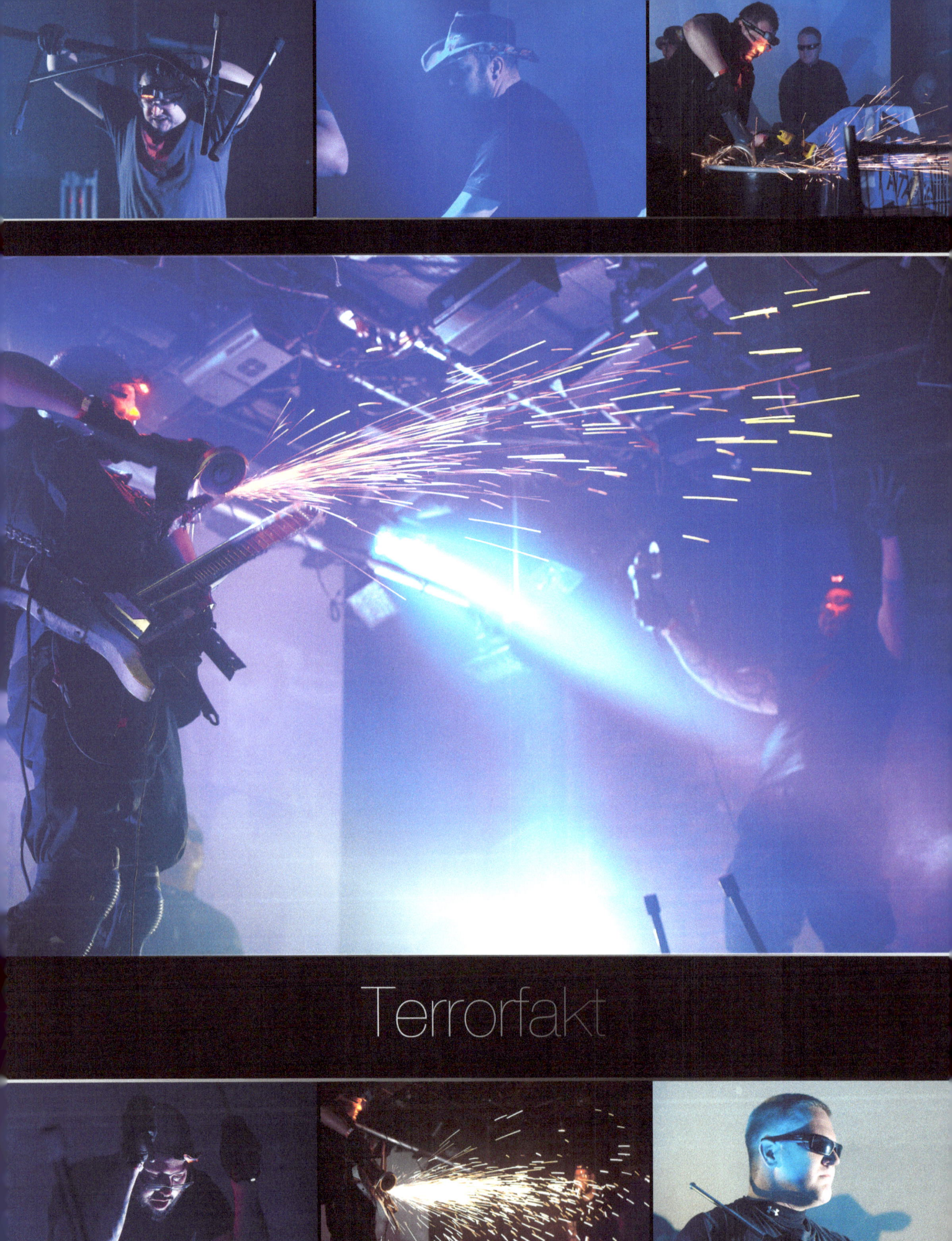

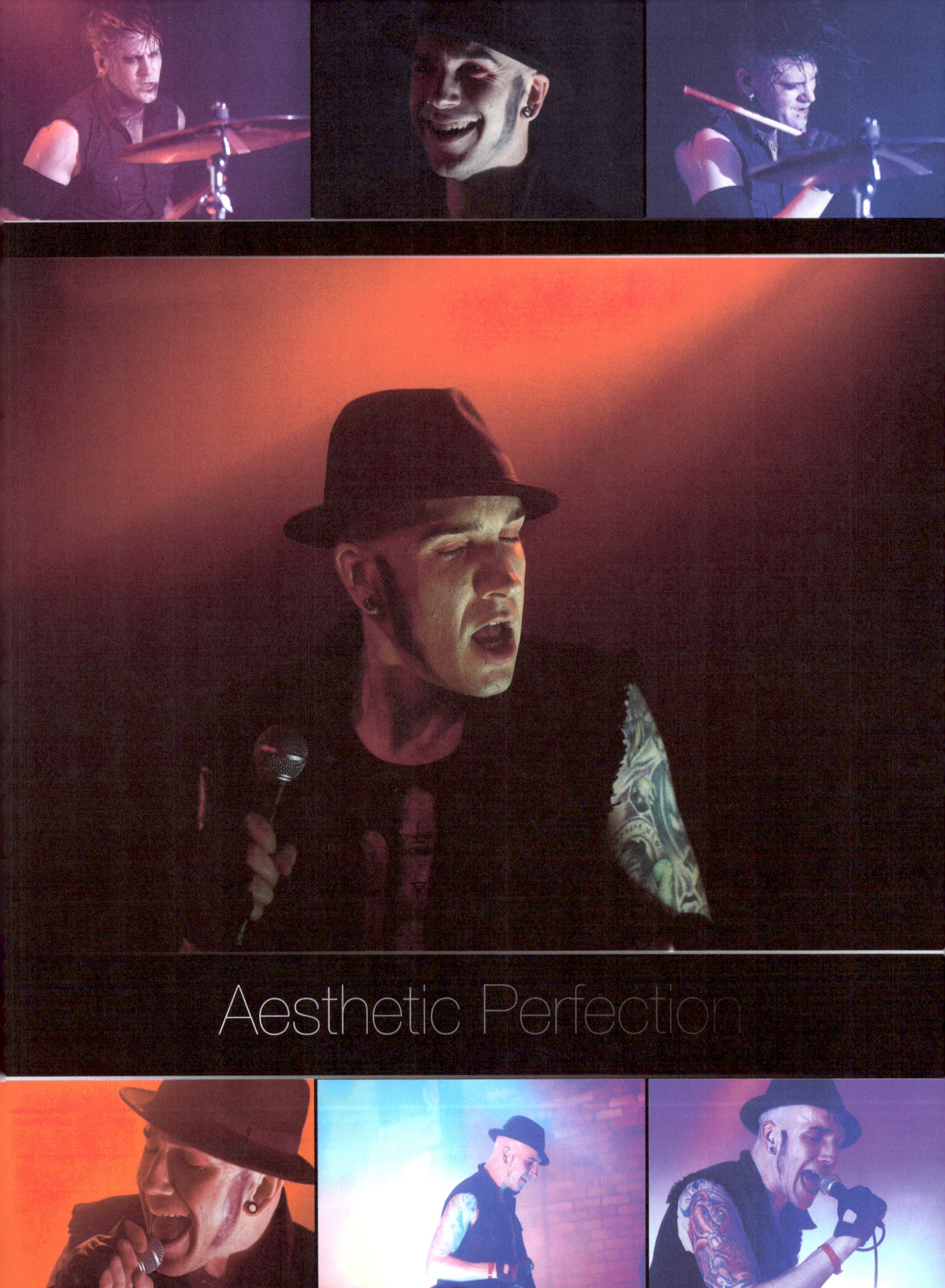

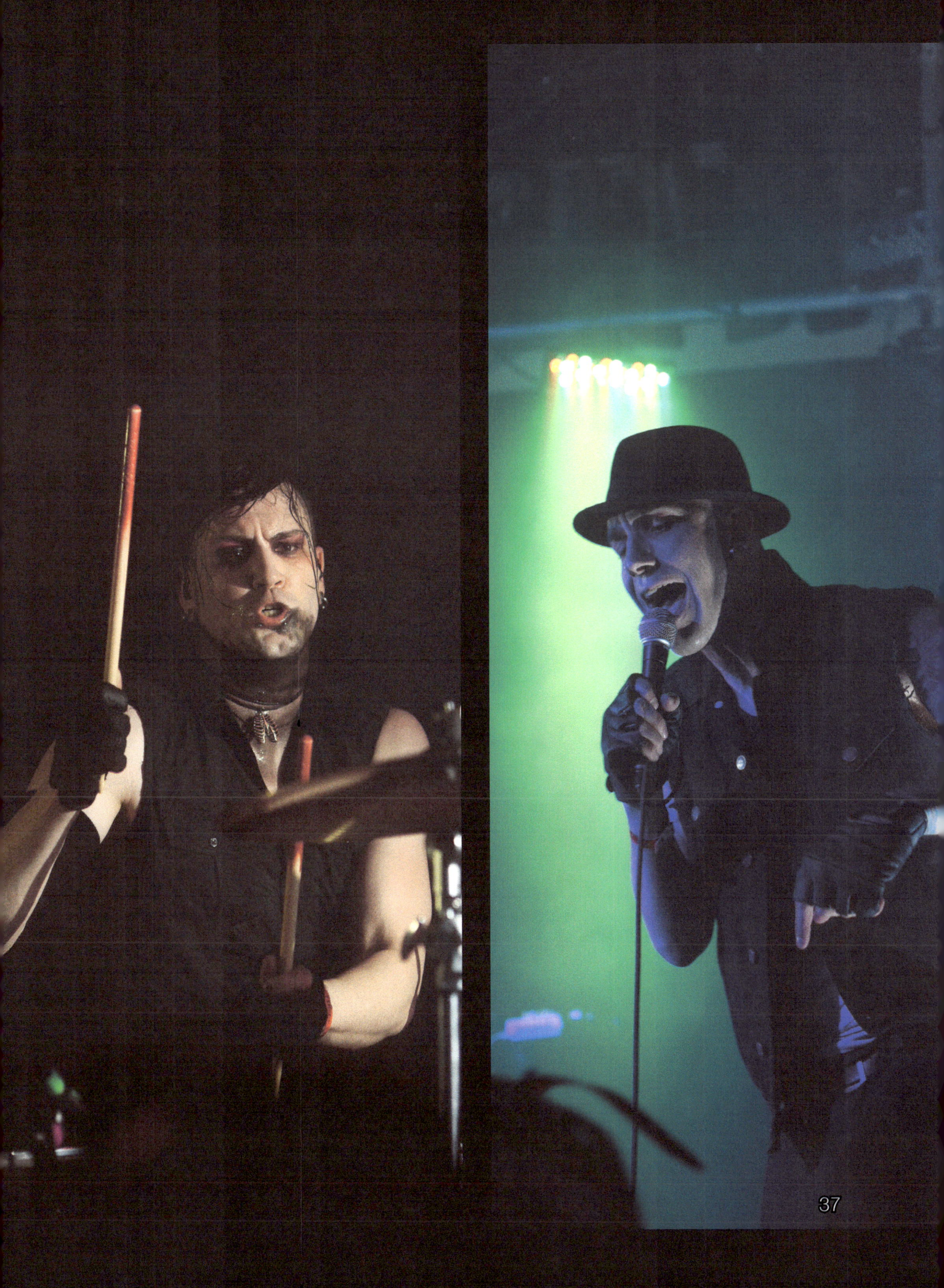

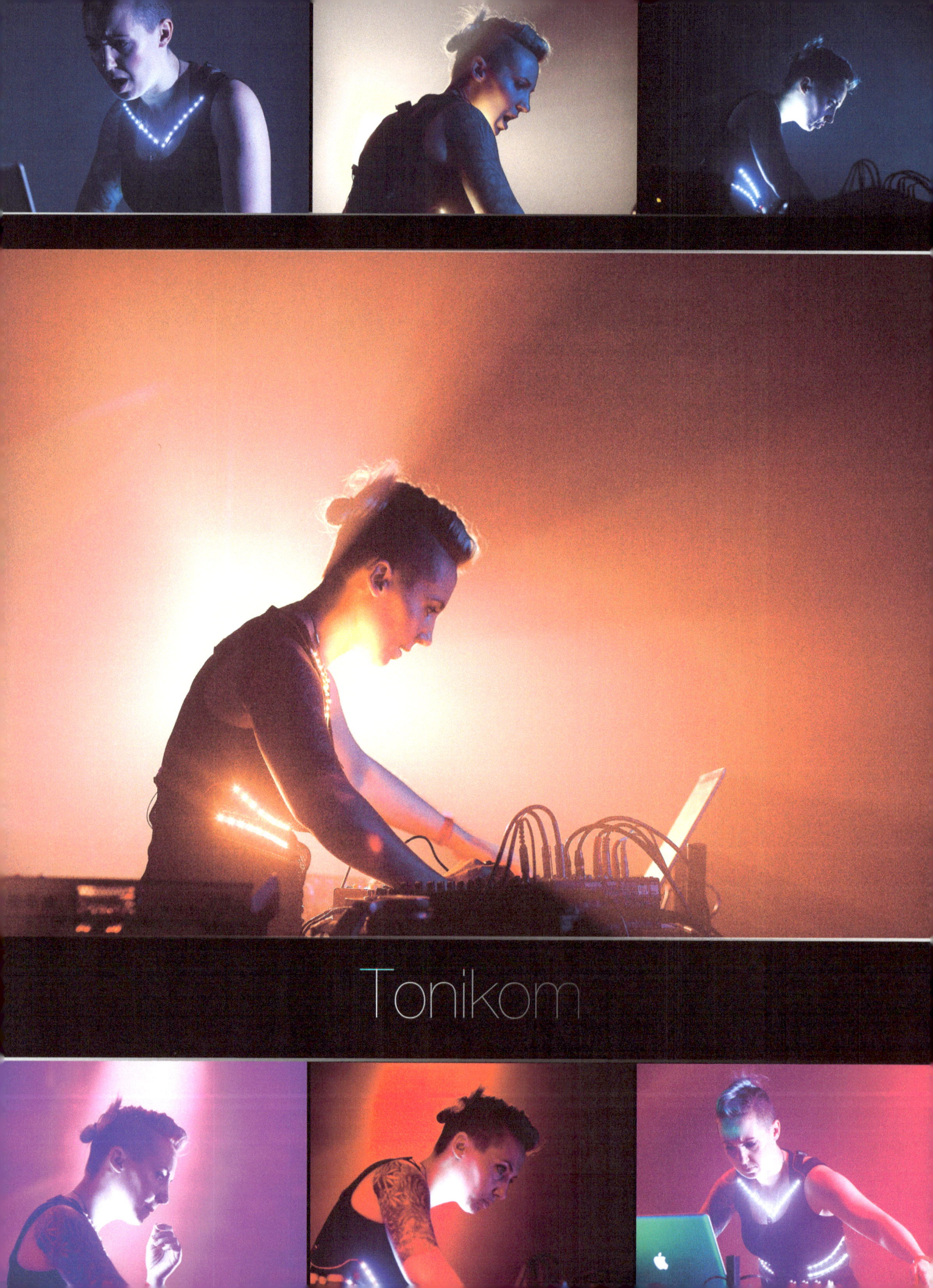

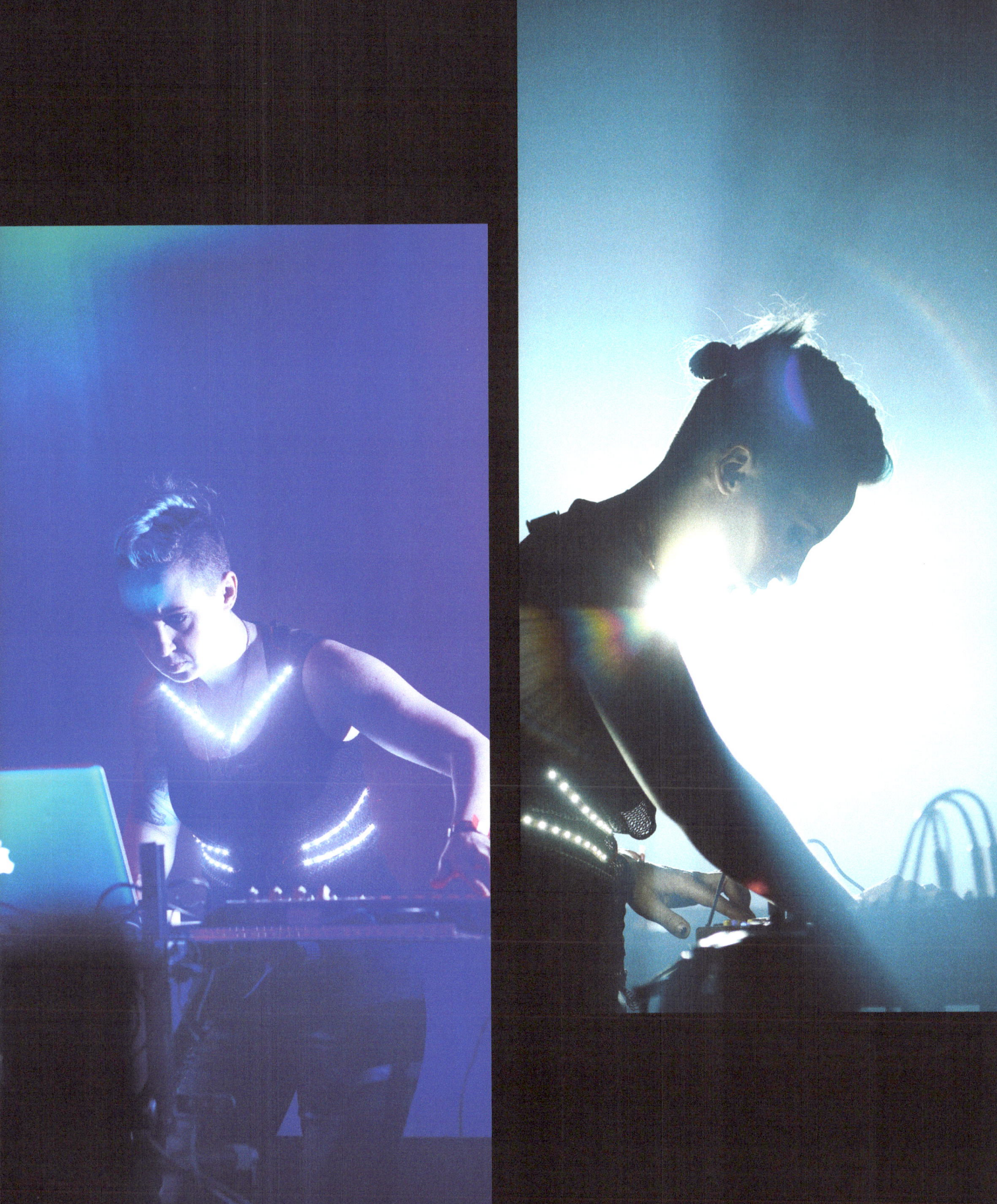

Seeing so many bands in such a short time takes a toll, but by the last day of Kinetik, even though the energy level is slightly lower, some of the most exciting spectacles traditionally take place. This year was no exception. Encephalon had equipment trouble, but instead of complaining about it, they worked with it, doing an unplugged vocal performance for their first track that drove the crowd wild. By the time the Gothsicles went on with their explosive show, the crowd was so excited that it was easy for frontman DarkNES to wade into the crowd during Gothsicles' anthem 'Balls', where he faced an ocean of hugs and high-fives from his loving fans. Ayria afterwards kept the crowd revved with her unique style of hard-edged synthpop, and Project Pitchfork thrilled all in attendance, as the EBM legends belted out their classic anthems and new material.

And before we knew it, it was all over. The worst time of the year; the longest time until the next Kinetik.
Which leaves us all wondering, what surprises does the festival have in store for us in 2014?

PHASE 4

Fractured	42
Encephalon	44
The Gothsicles	46
Ayria	48
Project Pitchfork	50
Panic Lift	52

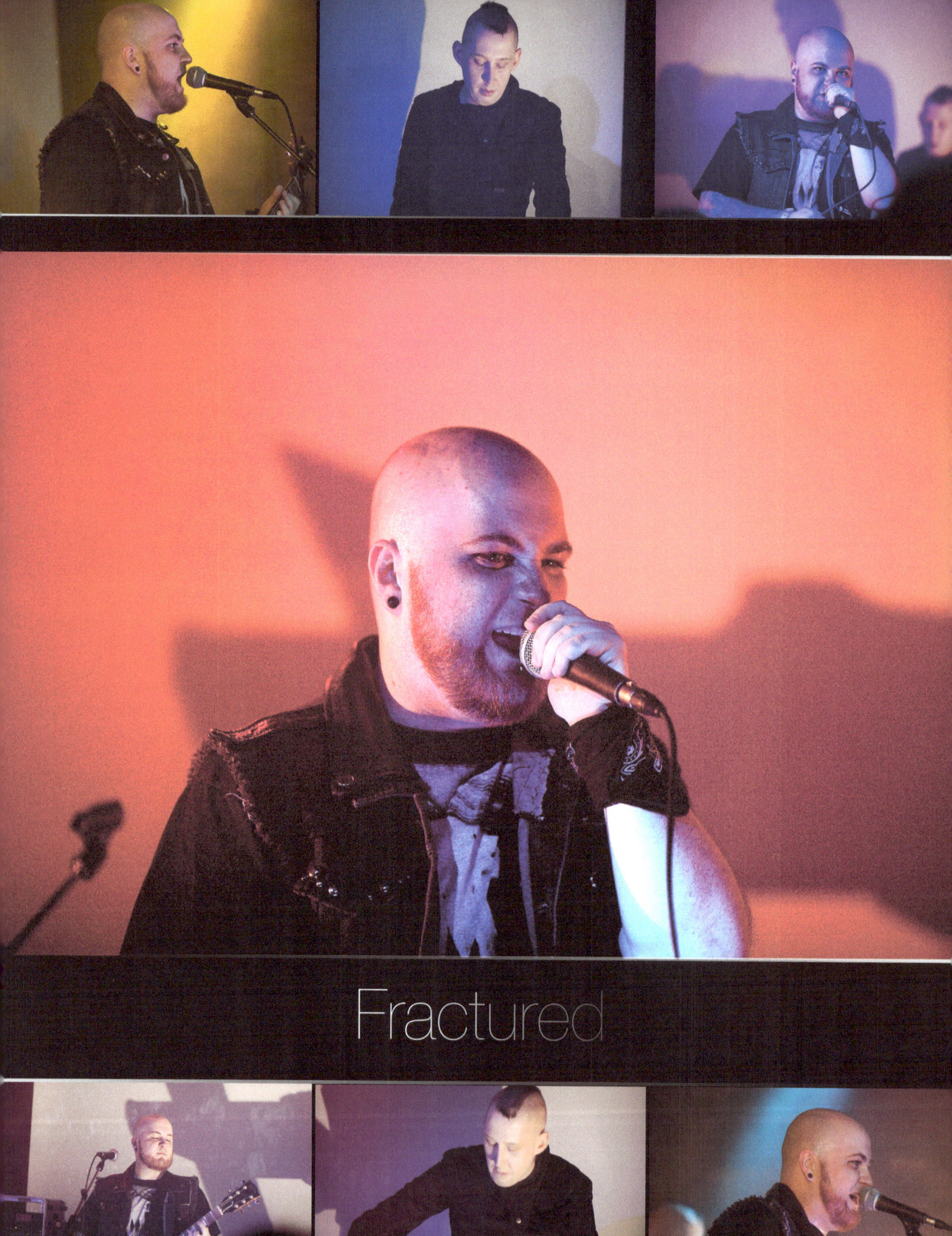

Fractured

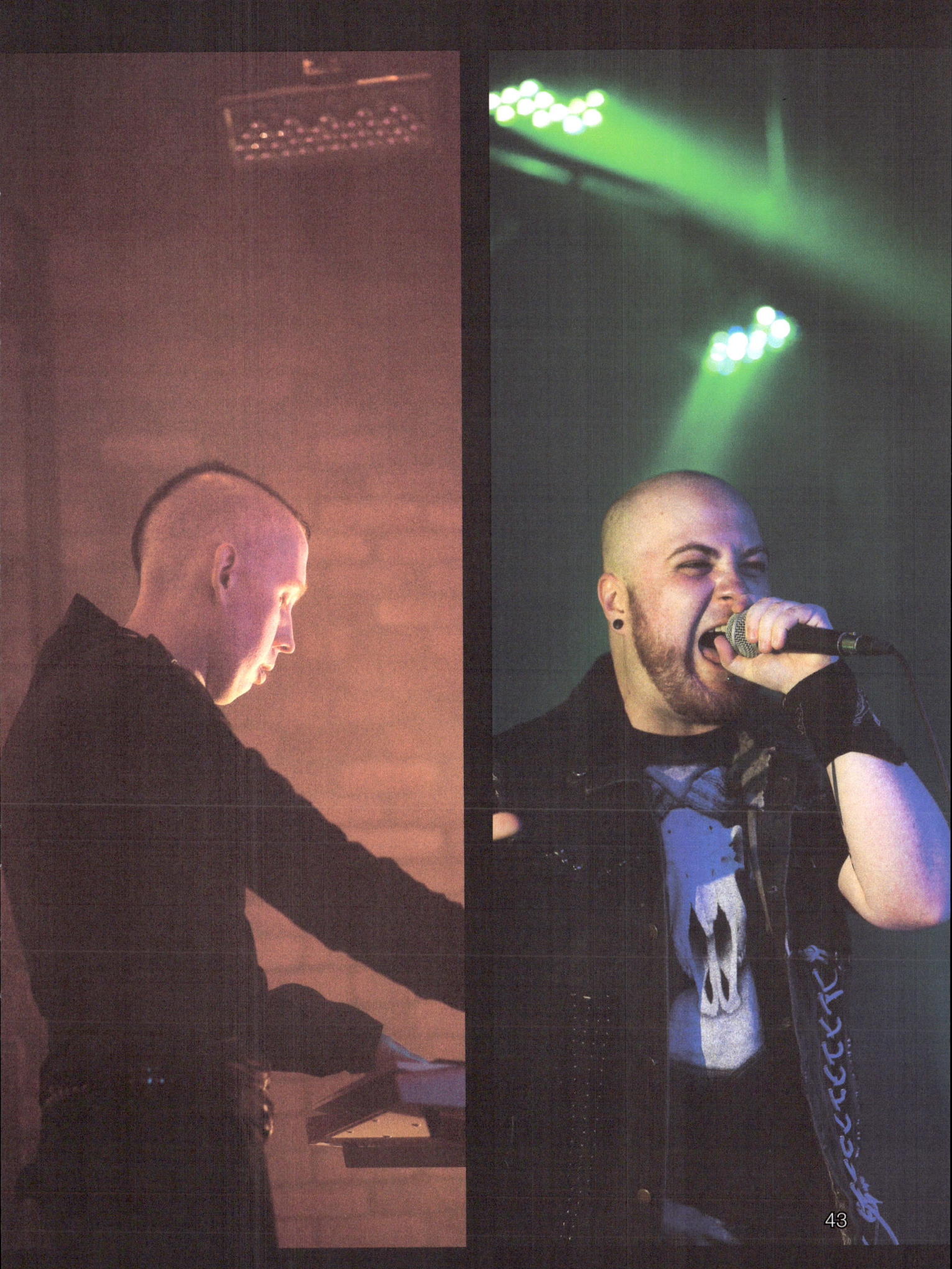

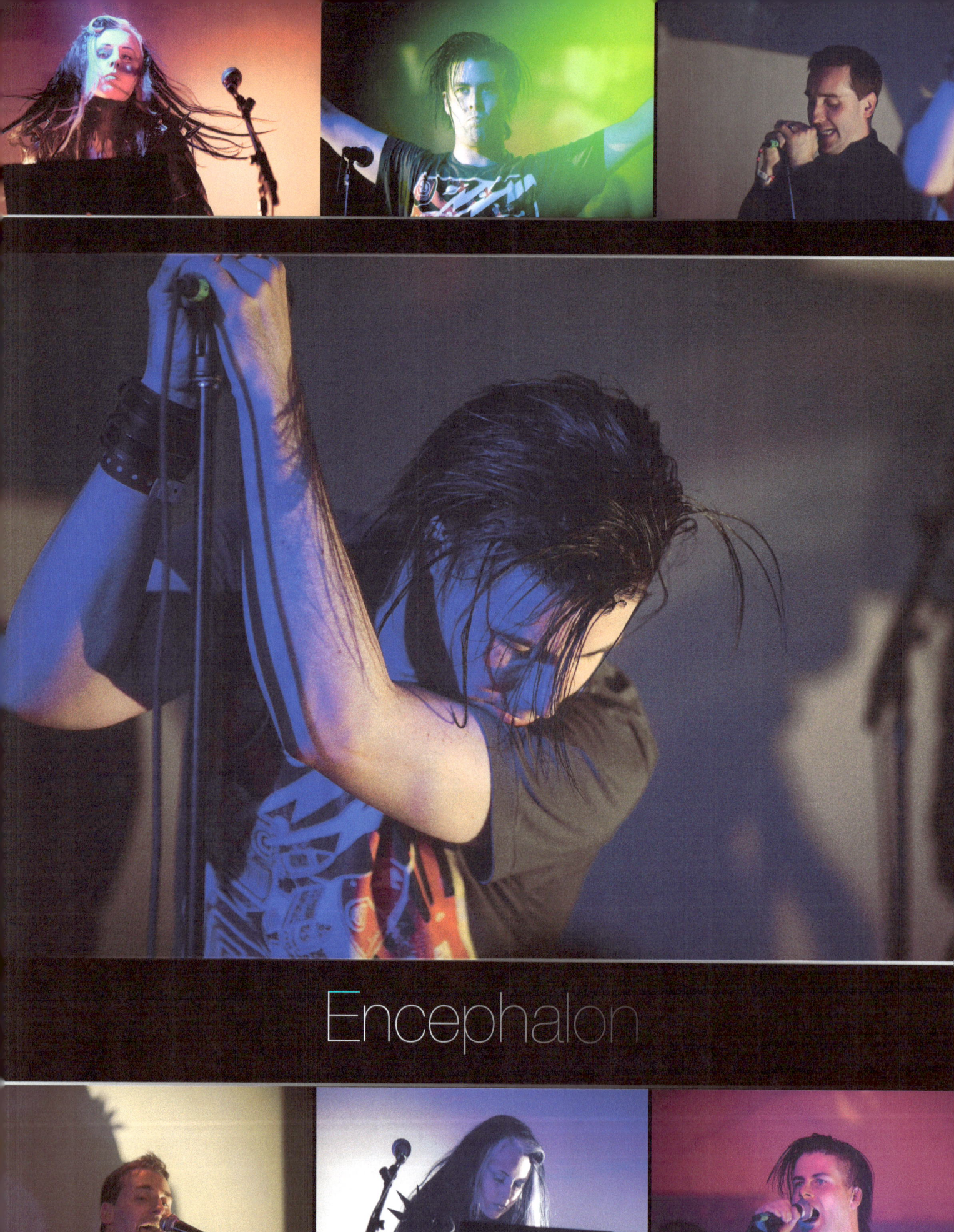

Encephalon

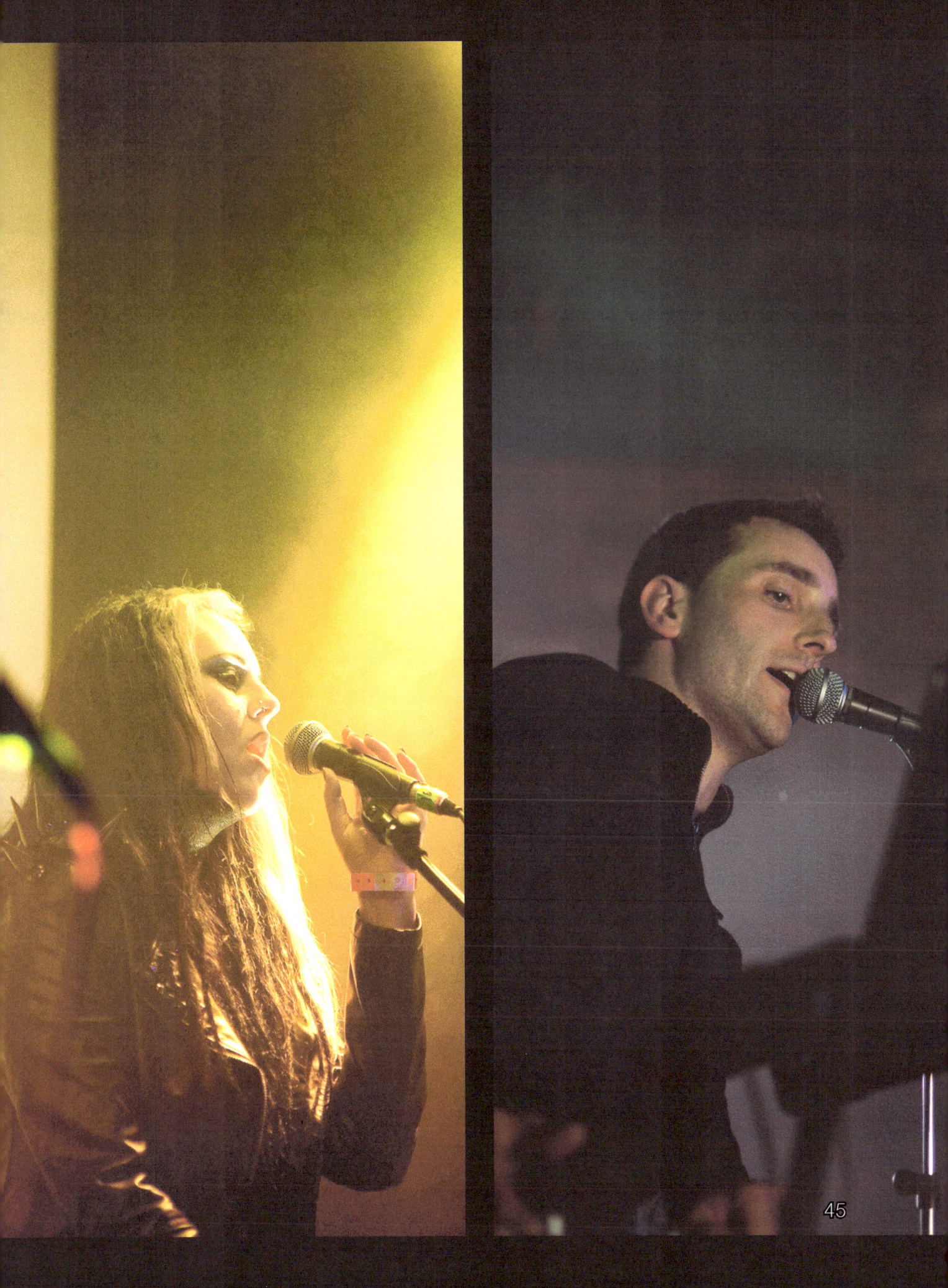

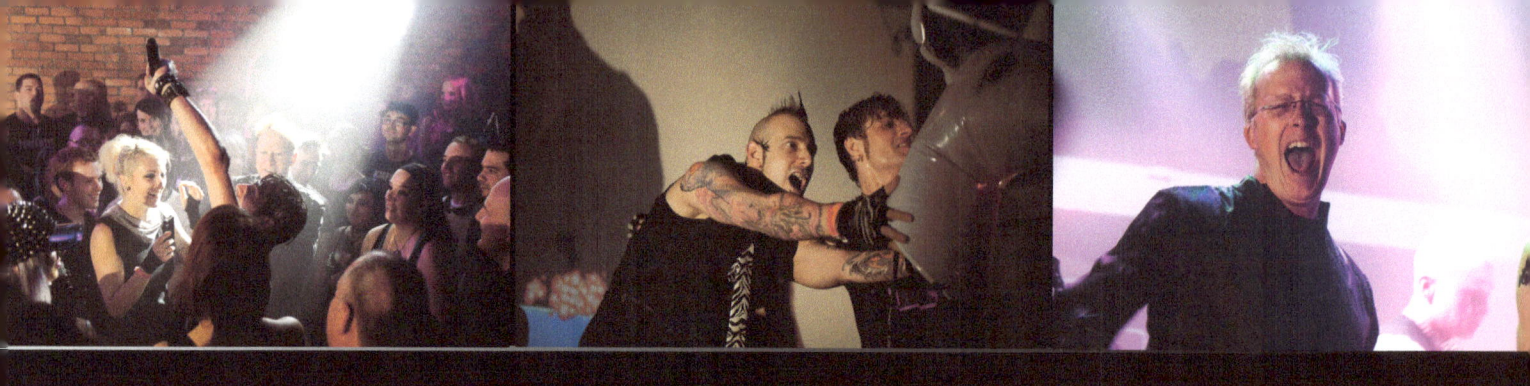

The Gothsicles

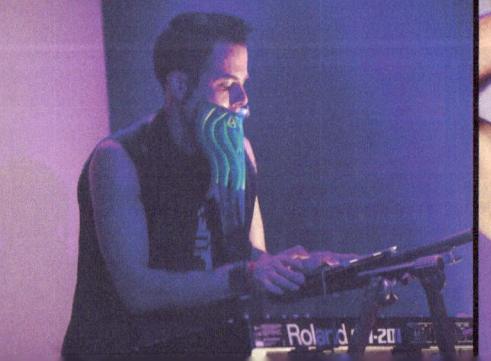
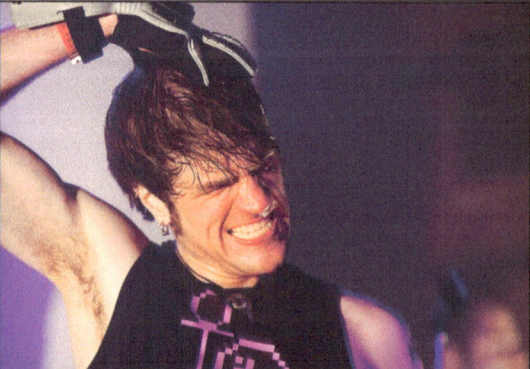
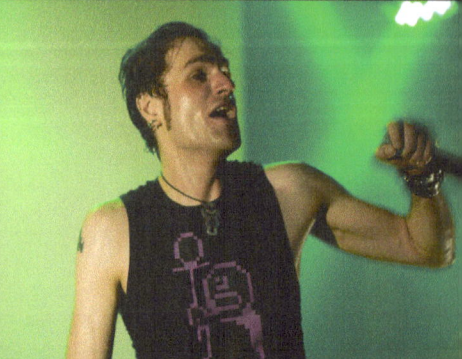

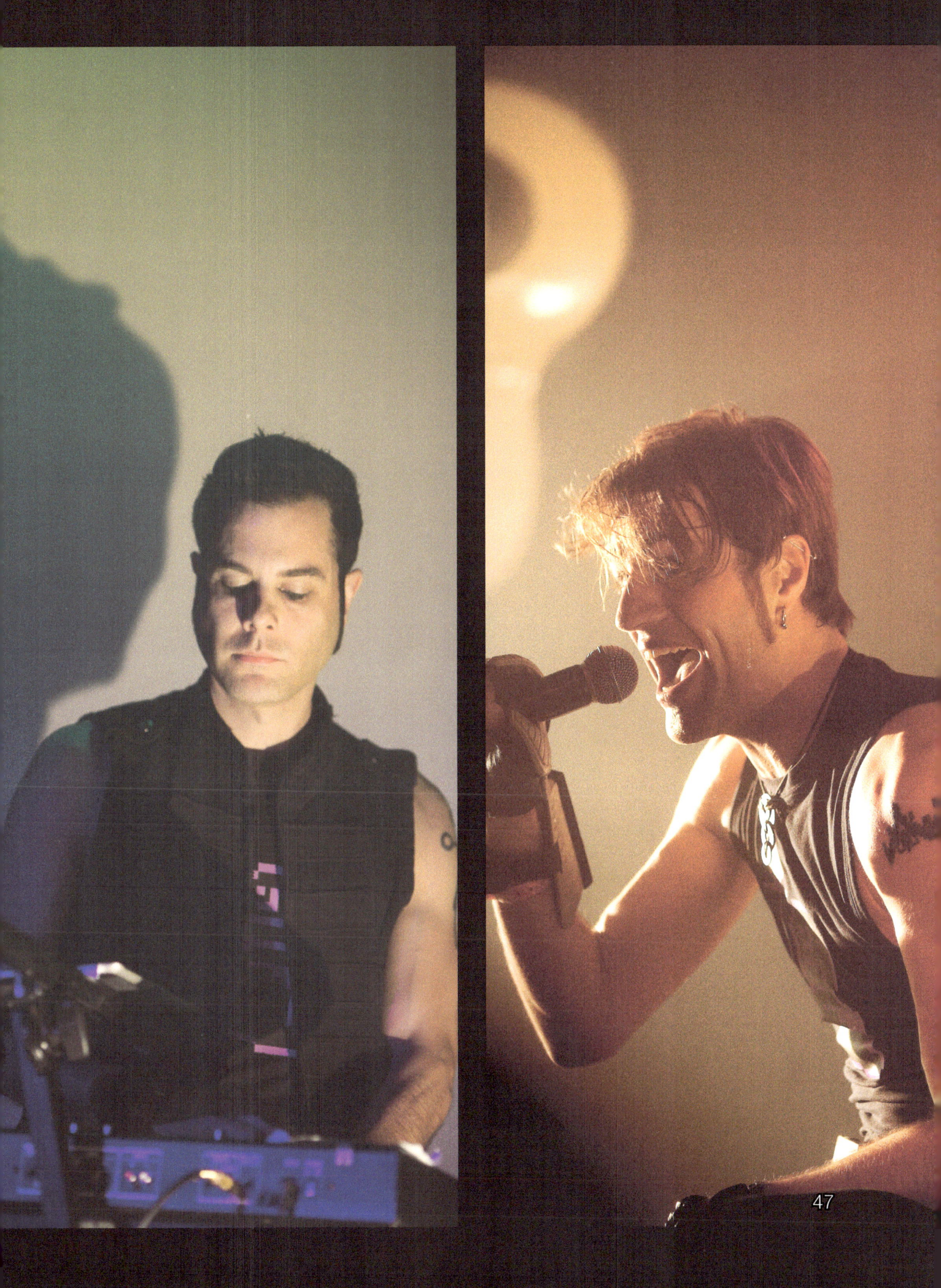

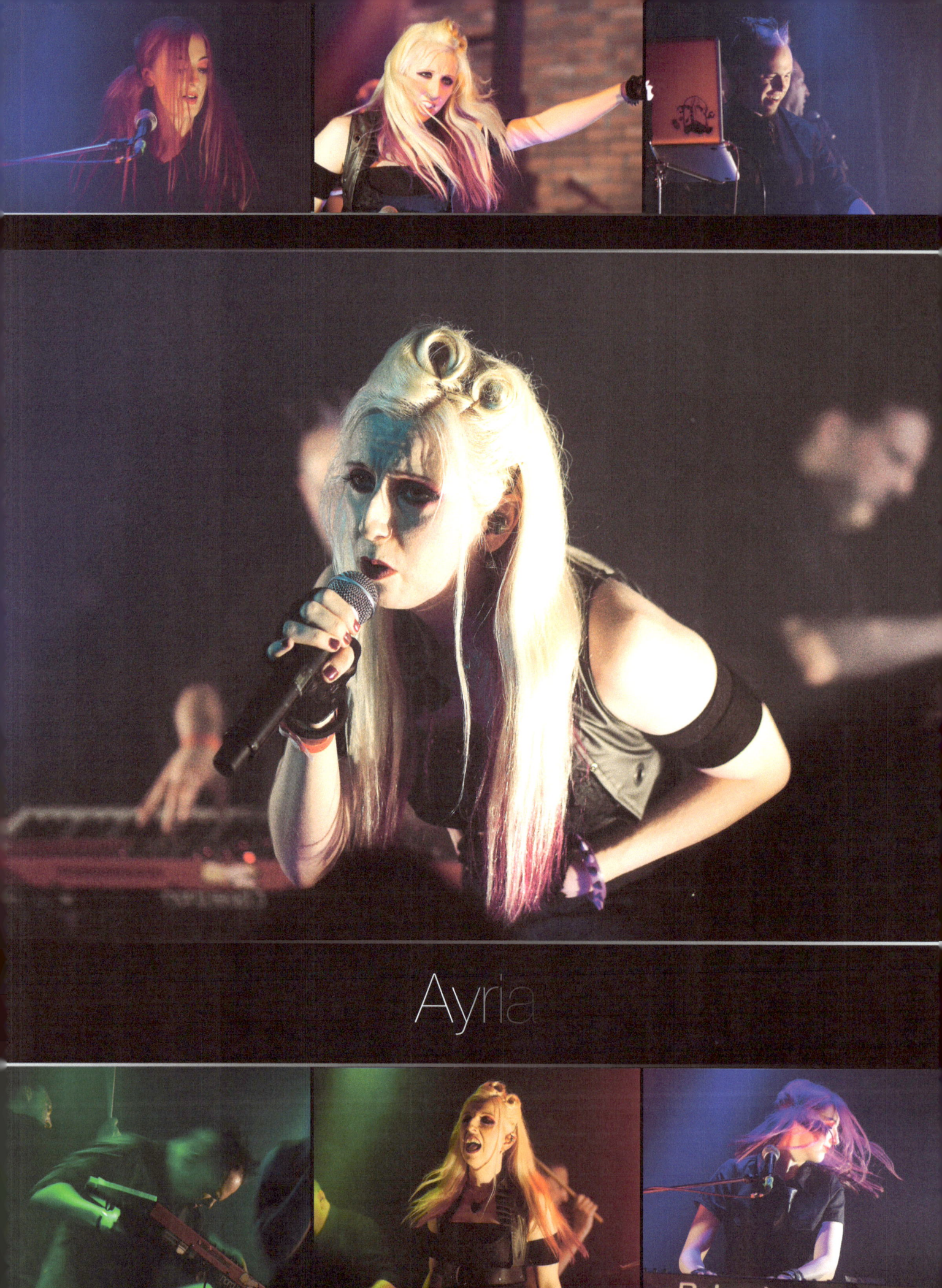
Ayria

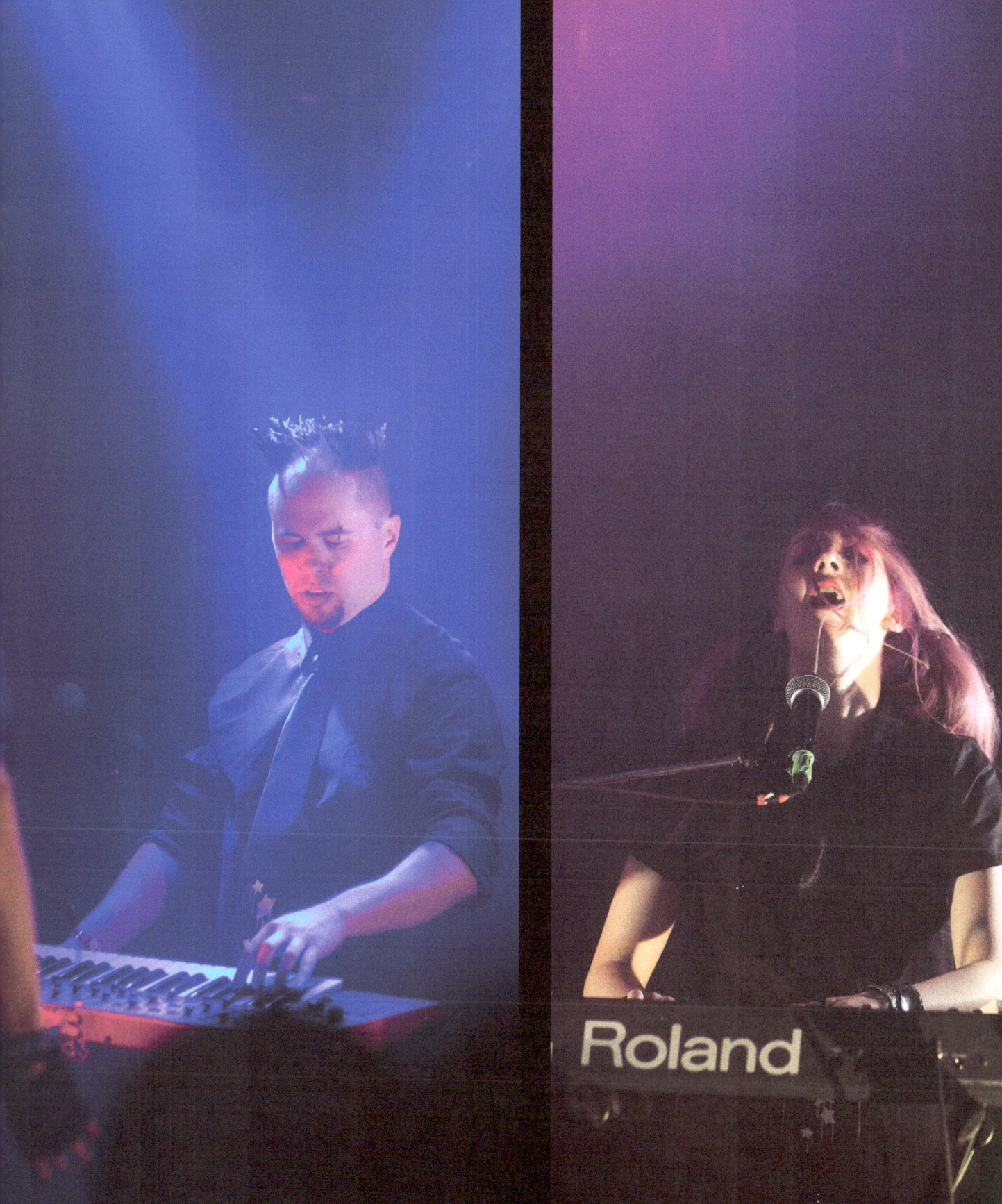

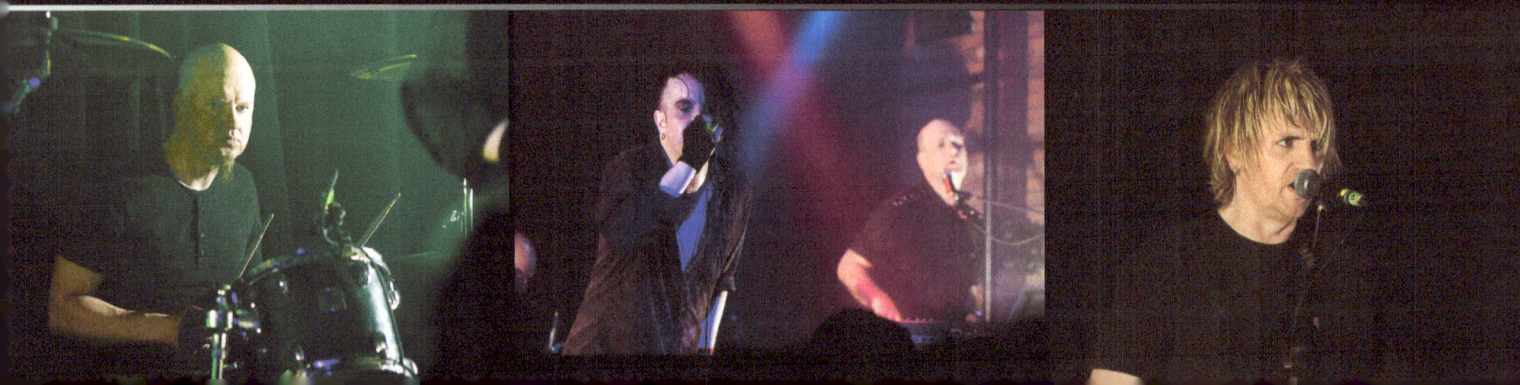

Project Pitchfork

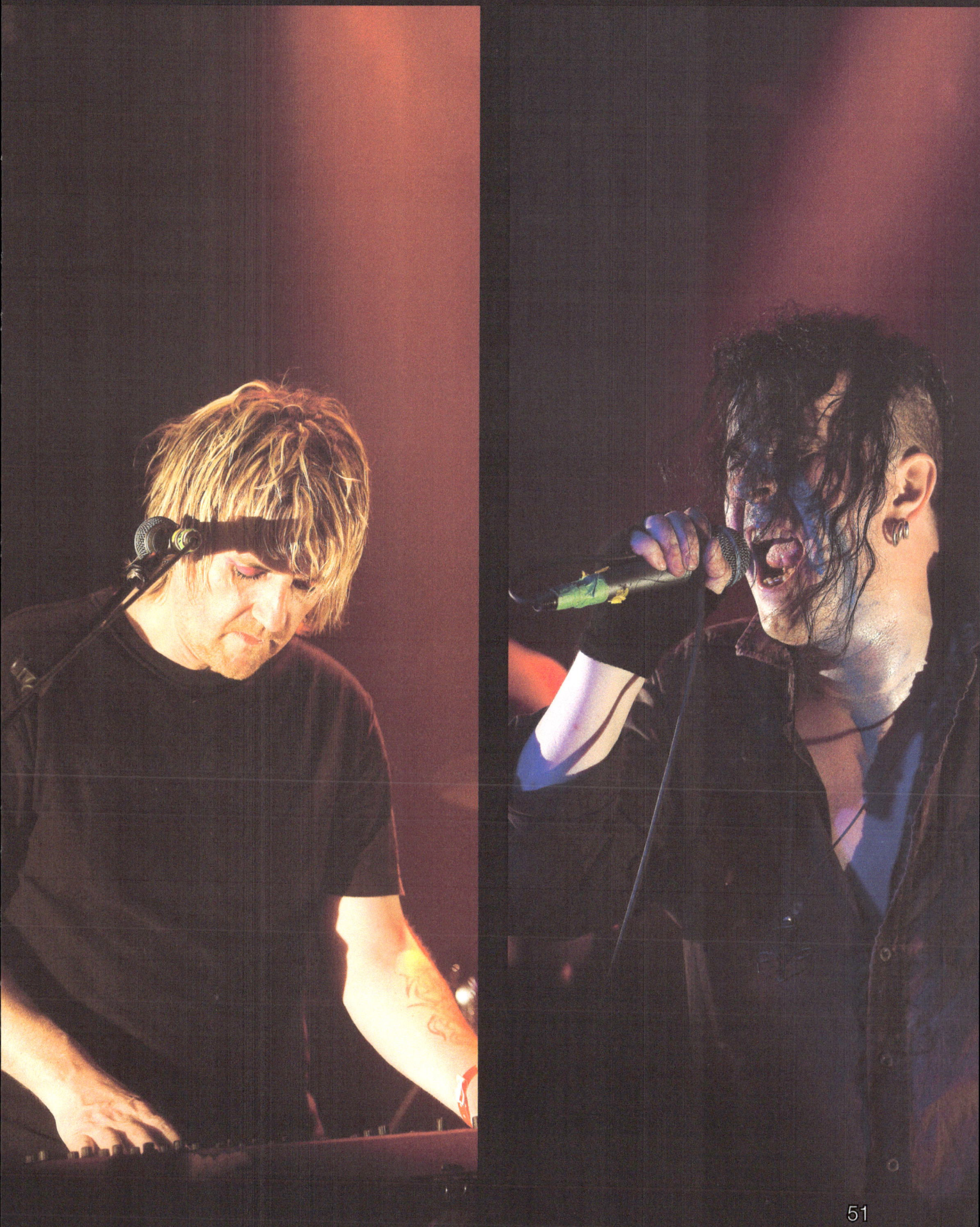

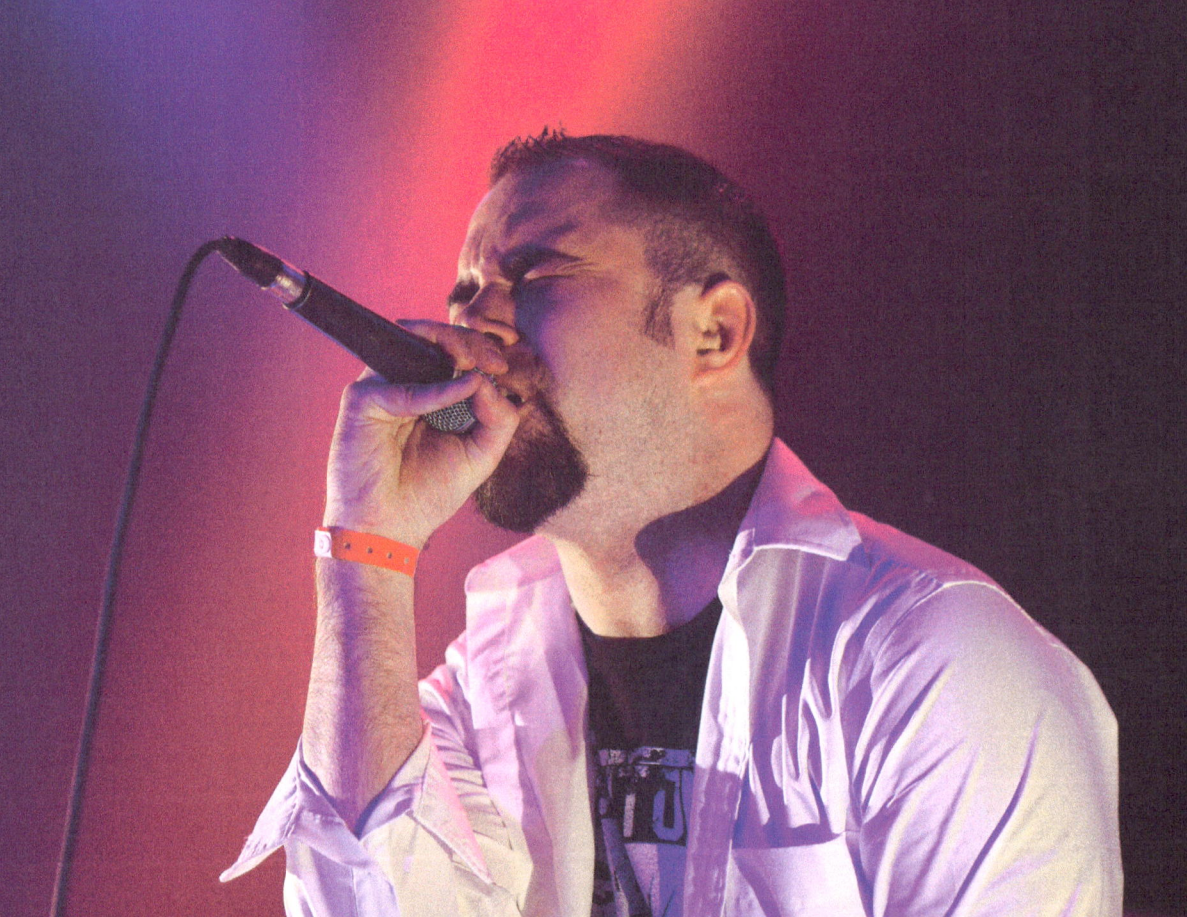

Panic Lift

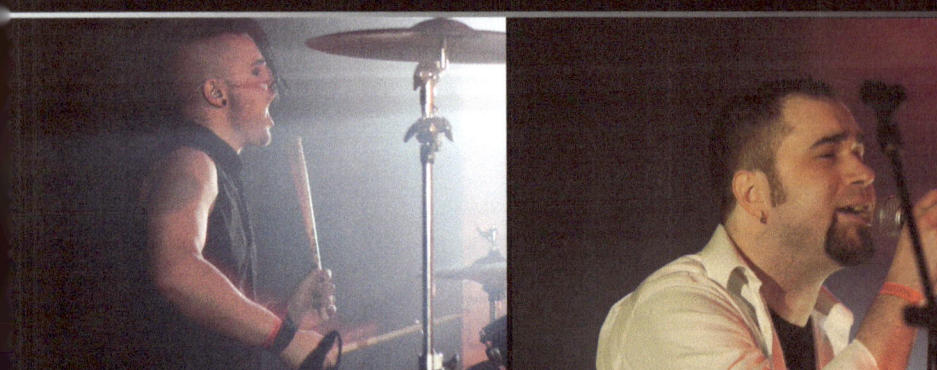
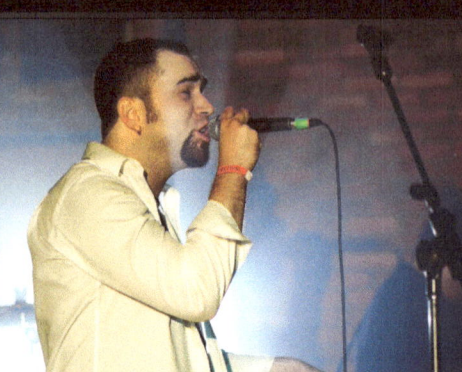

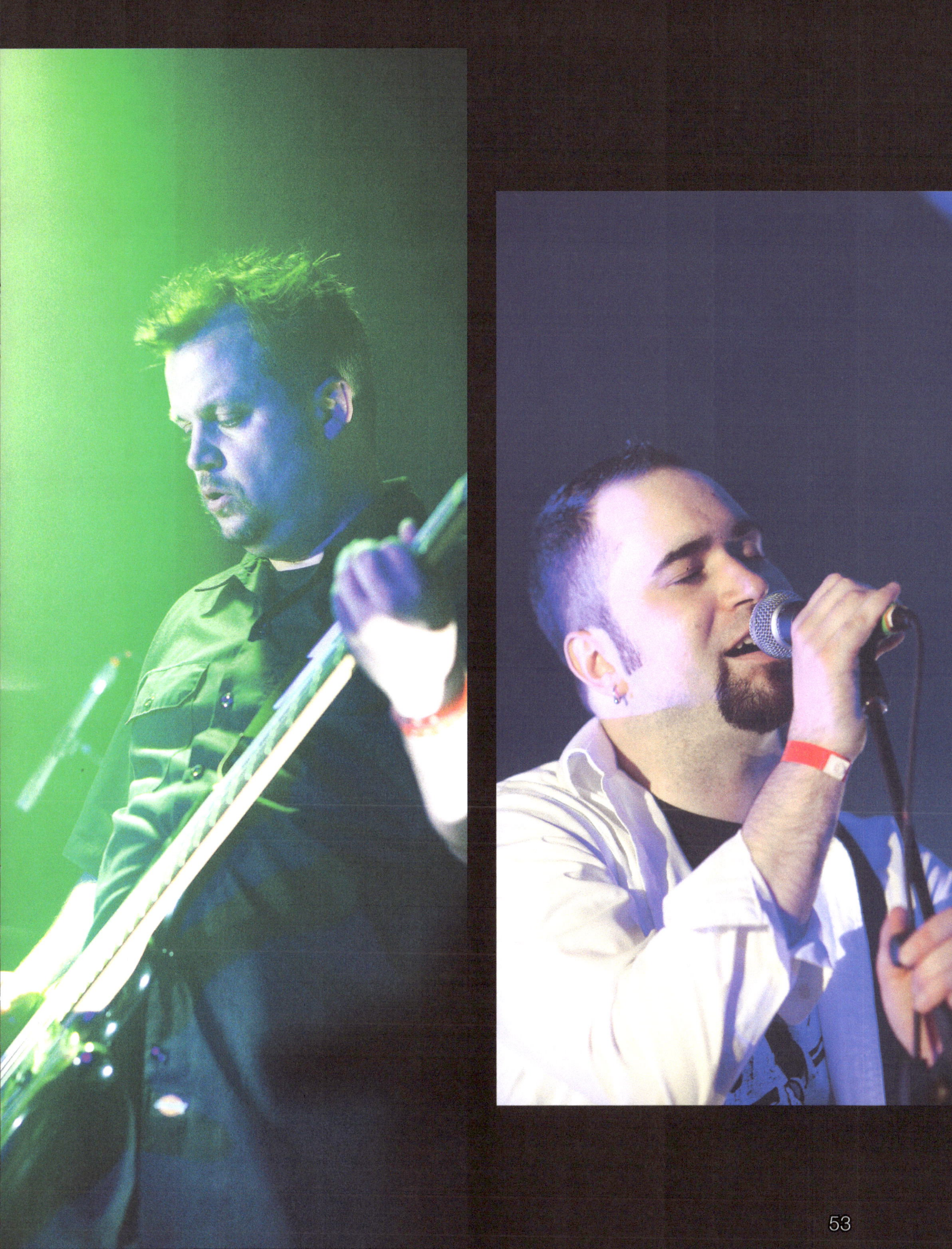

Festival Kinetik would like to thank
Le festival Kinetik voudrait remercier

all the bands playing on Festival Kinetik 5.5 and the ones that made the first 5.5 edition a huge success // tous les groupe de l'édition 5.5 du Festival Kinetik et tout ceux qui ont fait de l'édition 5.5 un succès.
Le Belmont, Artoffact Records / Storming the Base, Metropolis Records, COP International, Ben / Hellraver, Salt / Antzen, Protain, Neuwerk, Les Bières Boréale, Moog Audio Montréal, La Boite à Musique , ISN Radio, Vampirefreaks, Plastik Wrap, Das Bunker Los Angeles, Alfa Matrix, Hands Productions, Pronoize, Hymen, Hive Records, Infacted Records, Noitekk / Blackrain, Out of Line, Industrial Strength Records, Anh (miow!) Karine (bubu), Sébastien/Martin/Philippe (otto mans), Nathan, Mathieu, Isaac, Greg, John, Astro the super star woof!! Eugene miow !! & all the industrial music lovers around the world... & tous les amoureux de musique industrielle à travers le monde...

Kinetik Productions = Jean-Francois Fortin / Richard L. / Astro

www.festival-kinetik.net

$$E_K = \tfrac{1}{2} M V^2$$

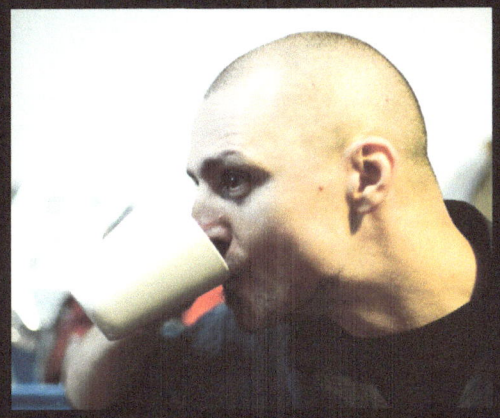

Adrian Onsen is a freelance photographer currently living in Southwestern Ontario, Canada with his family. Born from a love of music, Adrian ventures out to photograph portraits of both artists and dancers at local industrial nightclubs and concerts.

www.ingramcontent.com/pod-product-compliance
Lightning Source LLC
Chambersburg PA
CBHW050900180526
45159CB00007B/2739